Raphael

Text by Elena Capretti

GIUNTI

Publication designed by Giovanni Breschi

On the cover: the *Madonna della Seggiola*
(1513-1514), Florence, Galleria Palatina

Translated by: Paula Boomsliter
for Traduco Snc di Bovone e Bulckaen (Firenze)

© 1998
Giunti Gruppo Editoriale, Firenze

ISBN 88-09-21432-3

Contents

Umbria and Marches

" Raphael was born at Urbino, a most important city of Italy, in 1483, on Good Friday, at three in the morning...". From the very first words, a sort of sense of foreboding pervades Giorgio Vasari's 1568 biography of Raffaello Sanzio, since in truth the artist was not born on Good Friday (which in 1483 fell on 26 or 28 March), but on 6 April.

Son of the painter Giovanni Santi and his wife Magia di Battista Ciarla, Raphael was still quite young when he accompanied his father ("a painter of no great merit, but of good intelligence and well able to show his son the right way", according to Vasari) on his travels for work and his many visits to the court of Montefeltro in Urbino, since the time of Duke Federico a small though illustrious forge of culture and art, the best products of which had been Leon Battista Alberti and Piero della Francesca. In short, besides being a good father, Giovanni Santi was also a good teacher for Raphael: he introduced him to the works of those artists he mentions with admiration and esteem in his rhymed chronicles: Melozzo da Forlì, Mantegna, Perugino, Luca della Robbia, Leonardo, van Eyck, and Justus of Ghent. Thus, shortly before his death in 1494, Giovanni did not hesitate to send his son as apprentice to Pietro Perugino, whose *bottega* was at the time the best opportunity available for to one willing to learn. Raphael revealed himself a true *enfant prodige,* devoted to study, and a talented and prolific draftsman who was always observant and quick to judge and to assimilate.

"MAGISTER"
AT JUST SEVENTEEN
The *Angel* (Brescia, Pinacoteca Tosio Martinengo) is one of the fragments of the dismembered *Altarpiece of Saint Nicholas of Tolentino*, painted for Città di Castello. It was commissioned to "Magister Rafael Iohannis Santis de Urbino" and painted in 1501-1502. Damaged in the earthquake of 1789, all that remains today of the panel are four fragments: this *Angel*, the *Virgin* and the *Eternal Father* in Naples' Museo di Capodimonte, and another *Angel* in the Louvre. The Parisian museum acquired the latter fragment recently from a city taxi-driver who had inherited it.

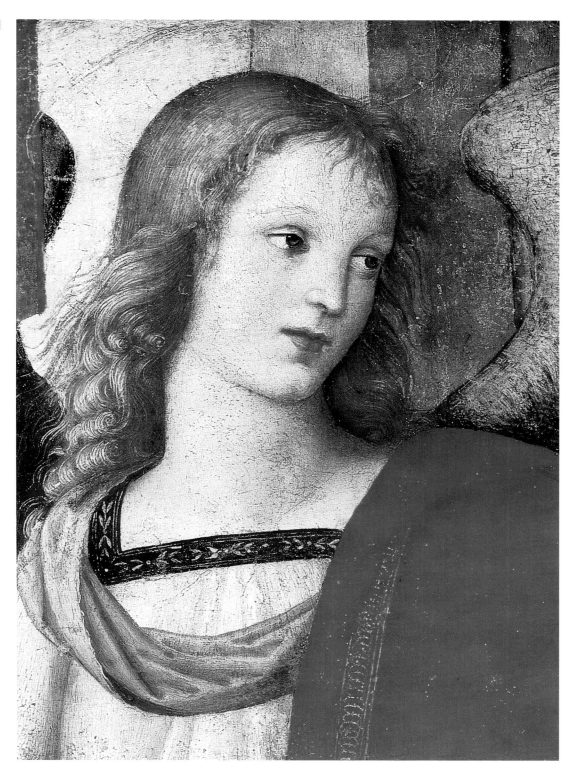

On 10 December 1500, at just seventeen, Raphael won his first contract to help paint an altarpiece; it was the *Coronation of Saint Nicholas of Tolentino*, commissioned by Andrea Baronci for the family chapel in Sant'Agostino in Città di Castello. The contract refers to Raphael as *magister* and stipulates that he will be aided in the work by the older Evangelista Pian di Meleto, his father's assis-

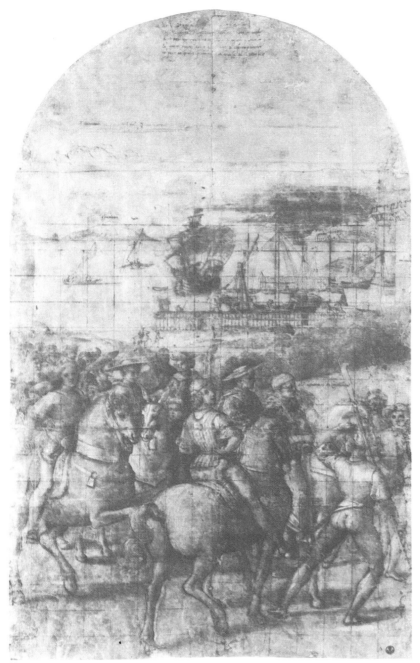

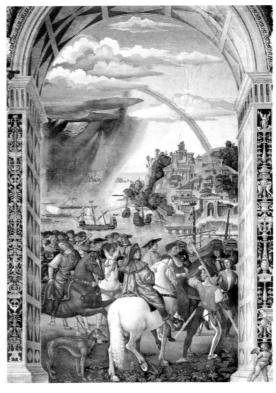

"AN EXCELLENT
DRAFTSMAN"...
Raphael drew the
cartoon for the
*Departure of Aeneas
Silvio Piccolomini for
Basel* (on the left;
1502; Florence,
Uffizi, Drawings
and Prints Collection)
to help Pinturicchio,
who was frescoing
the Piccolomini
Library in Siena.

... WHO AIDED
PINTURICCHIO
Raphael's cartoon
sparkled with his
genius for composition,
but Pinturicchio seems
not to have profited
much by it. His
*Departure of Aeneas
Silvio Piccolomini for
Basel* (above; 1502-
1508) is flattened
against the surfaces
of the sea and the sky.

tant since 1483. In Città di Castello, where the unquestioned pro-
tagonist had until that time been Luca Signorelli, Raphael worked
on and off for four years. By 1499-1500, he had painted the *Stan-
dard of the Holy Trinity* (Città di Castello, Pinacoteca Comunale;
today in very poor condition) as a votive offering for deliverance
from the plague. The *Crucifixion* (London, National Gallery), in-
stalled on the Gavari altar in San Domenico in 1503, is a faithful
and refined translation of the models furnished by Perugino. In
1504, he painted the *Marriage of the Virgin* for the Albizzini family
chapel in San Francesco.

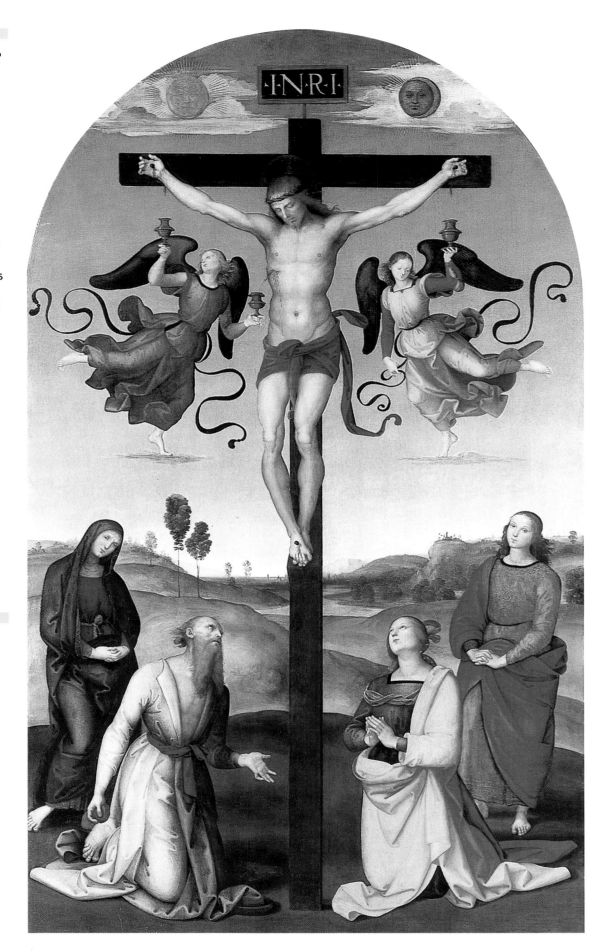

RAPHAEL OR PERUGINO?

Vasari tells us that were the *Crucifixion* of 1503 (London, National Gallery) not signed by Raphael it could well be believed a work of Perugino.

In the background there seems to be represented Florence from the Umbrian approach: a precious clue indicating an early trip by Raphael to the Tuscan city.

A VOTIVE OFFERING FOR THE PLAGUE

Probably following the plague epidemic of 1499, Raphael painted a processional banner for the Society of the Holy Trinity (Città di Castello, Pinacoteca Comunale).

In the lower right corner of the facing page is the verso of the standard with the *Creation of Eve*.

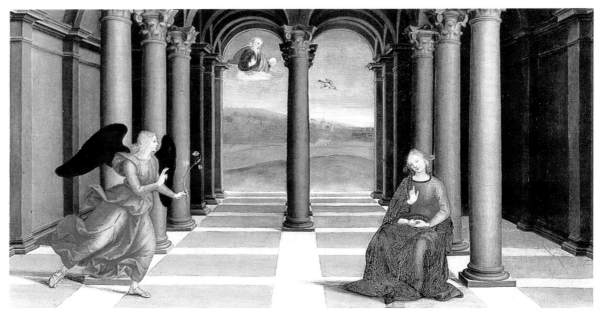

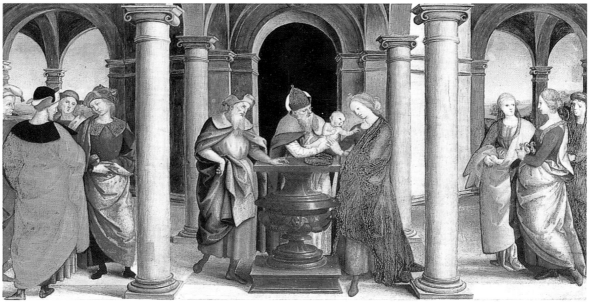

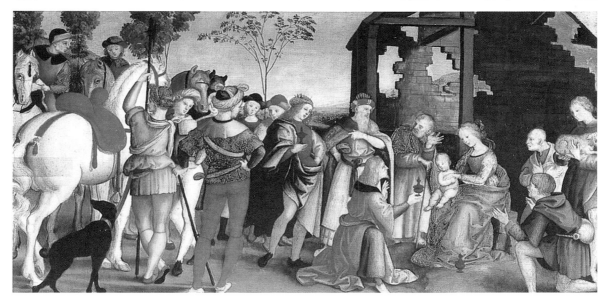

SOLID PERSPECTIVE
The *Coronation of the Virgin* (1502-1503, Vatican City, Pinacoteca Vaticana), with its predella showing the *Annunciation*, the *Presentation in the Temple* and the *Adoration of the Magi* (facing page, from top to bottom) was installed in San Francesco in Perugia in the Oddi family chapel.
The solid perspective construction of the Sepulchre and of the predella as a whole, together with the attention given to the characterization of the faces, are evidence of the progress being made by Raphael in going beyond Perugino's manner.
At the same time, these works provide evidence of his first trips to Rome and Florence. Shortly following this work, Raphael went to work for the Baglioni family, the implacable political adversaries of the Oddis.

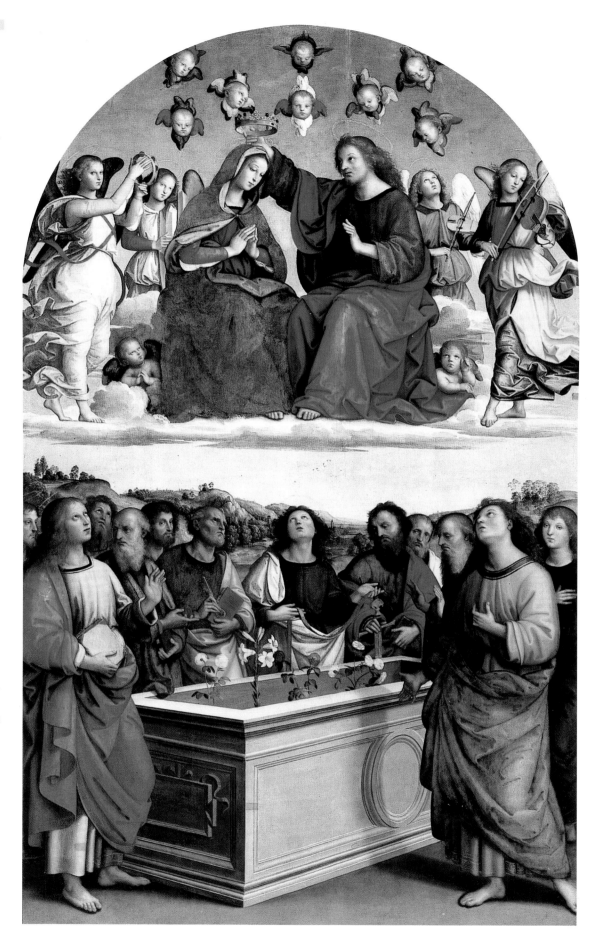

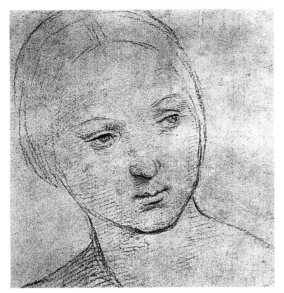 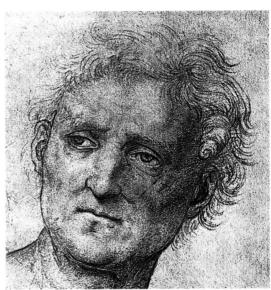

DRAWINGS-PORTRAITS
The *Study of a Woman's Head* (Oxford, Ashmolean Museum) and the *Male Head* (London, British Museum) are generally considered portrait studies for the *Marriage of the Virgin* (1504; Milan, Pinacoteca di Brera. See p. 42).
The method of making studies of the faces on separate sheets and then uniting them directly during the execution of the painting had already been amply experimented by Perugino.
The *Blessing Christ* (1504; Brescia, Pinacoteca Tosio Martinengo) on the facing page was probably painted at about the same time as the Brera altarpiece or during Raphael's stay in Florence.

In the meantime, Raphael's fame was spreading, and brought him much work in Perugia as well. Here, like in Città di Castello, it was not long before Perugino's established success was shaken and clouded by that of his former pupil. The *Coronation of the Virgin*, which by 1503 was installed in the chapel of Maddalena degli Oddi in San Francesco, aroused particular clamor; in about the same year the abbess of the convent of Monteluce, having viewed the altarpiece, ordered another painting of the same subject from that "outstanding master recommended by many citizens ... who had viewed his works". The nuns nevertheless had to wait until 21 June 1525 to see their painting; nor was it by Raphael himself, who had died before executing the work, but by members of his workshop.

It is probable that Raphael, driven by the desire to learn and to broaden his horizons, traveled beyond the confines of Umbria and the Marches to Venice, Padua, Florence, Orvieto and even Rome in the early years of his career. One important occasion was offered him by his friend Pinturicchio, who, since he "knew him to be an admirable draftsman" (Vasari), took Raphael with him to Siena when he was engaged there to decorate the library adjacent to the cathedral with scenes from the life of the humanist Enea Silvio Piccolomini. Raphael "made some of the drawings and cartoons for that work" and in particular supplied the sketches for the *Meeting of Federico III with Eleonora of Portugal*, formerly in the Baldeschi collection in Siena, and for the *Departure for the Council of Basel*, now in the Uffizi.

On this occasion the young and enthusiastic painter was unable to resist the temptation to take a side-trip to Florence – for the moment, however, as a simple tourist.

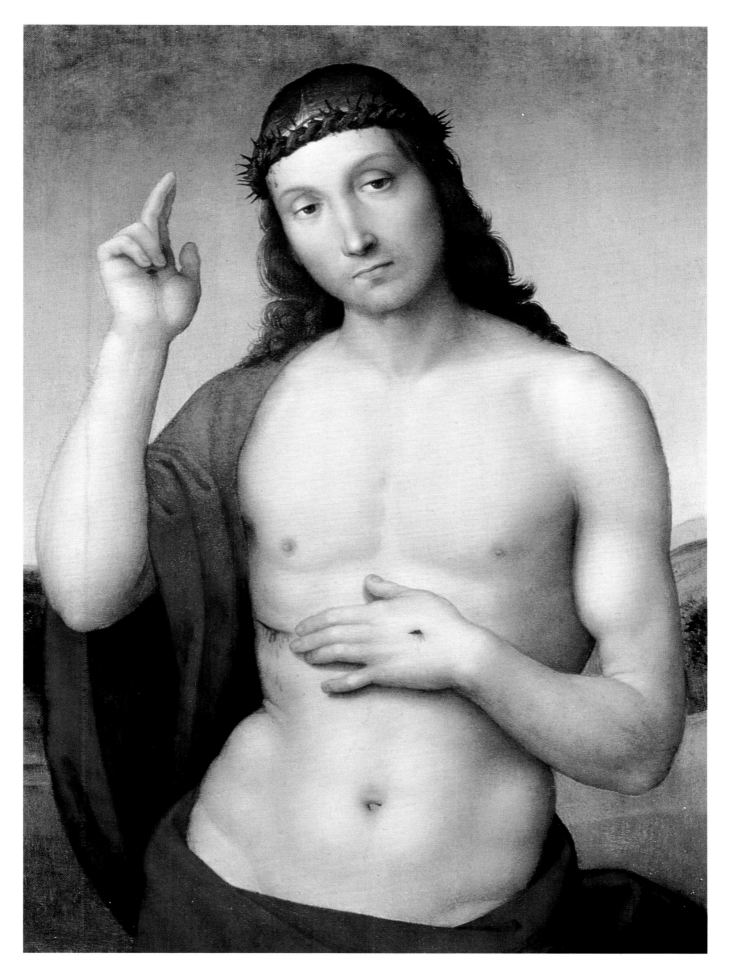

The Florentine Period

In late 1504 Raphael, hungering for important public commissions, came to Florence and was admitted to the presence of the gonfaloniere of the Republic, Pier Soderini, with a letter of recommendation in good order. It was written on October first by Giovanna Feltria, the duchess of Sora and widow of Giovanni della Rovere, lord of Senigallia and prefect of Rome. She was the sister of Guidobaldo da Montefeltro, duke of Urbino. Even though Soderini could not in good conscience avoid reading those lines attentively, Raphael did not receive the prestigious commissions he was hoping for. He did, however, have the opportunity to prolong his stay in Florence in a period among the most fertile, intense and fascinating the city has ever known. The unquestioned protagonists of that felicitous and vital season were Leonardo and Michelangelo, who like others had returned to Florence in hope of obtaining the important commissions it seemed Soderini was offering. When he carried Giovanna Feltria's letter to the gonfaloniere in Palazzo Vecchio, Raphael most certainly paused in Piazza della Signoria to admire Michelangelo's statue of *David*, the emblem of the republican spirit, which had been installed on the *ringhiera* in front of the palace a short time before, on 8 September 1504. And once inside, someone must surely have shown him the wall that was waiting for

"RAPHAEL URBINAS"
IN FLORENCE
Raphael came to Florence in late 1504 with a letter of presentation from Giovanna Feltria, the widow of the prefect of Rome. He had signed the *Marriage of the Virgin* (see p. 42), only a short time before, as we read in the inscription on the small temple, shown in the detail below.
In the Tuscan city, Raphael undertook a great number of compositions destined for the private rooms of the Florentine patricians, among which the *Madonna of the Belvedere* on the facing page (Vienna, Kunsthistorisches Museum), dated 1506 on the neckband of the Virgin's bodice.

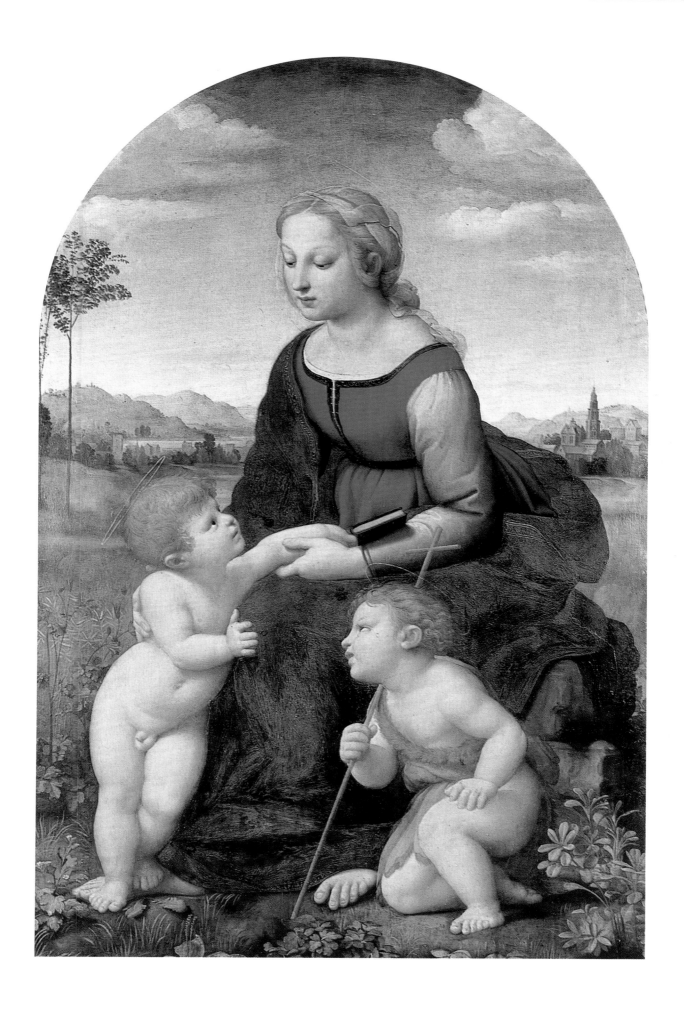

LEONARDO: A FUNDAMENTAL INFLUENCE Raphael studied Leonardo's variations on the theme of the Virgin and Child. The sketch on the left, for the *Madonna with a Cat* (Bayonne, Musée Bonnat), is an example. Raphael took his inspiration from a study dated 1505-1506 (right), today in London's British Museum. The *Holy Family with a Lamb* (Madrid, Prado), dated 1507, is also evidently derived from Leonardo's work.

Leonardo and Michelangelo to begin work, respectively, on the *Battle of Anghiari* and the *Battle of Cascina* in the majestic Hall of the Five Hundred. A vain hope, as it turned out, since neither work ever proceeded beyond the cartoon stage – but Raphael and others nevertheless learned from them. And finally, some time later, perhaps someone accompanied the artist to view the *Last Judgement* frescoed by Fra' Bartolomeo and Mariotto Albertinelli in the San Marco monastery, where Fra' Girolamo Savonarola had been prior.

Raphael fit in well in the Florentine artistic milieu, thanks in part to his good manners and his courtesy and to that innate kindness that was to make of him a successful court gentleman. Although he was a foreigner – and a potential competitor – he became friends with a number of artists. Raphael soon made intimate friendships with writers, musicians, businessmen and influential figures of that high middle mercantile class for which he painted enchanting – and famous – paintings for his patrons' chambers, those *"care madonne"* that so fascinated later English travelers, including the poet Robert Browning. An example is the triad composed of the *Madonna of the Goldfinch* (now in the Uffizi; see p. 44), painted for Lorenzo Nasi, the *Madonna del Prato* (Vienna, Kunsthistorisches Museum), dated 1506 and painted for Taddeo Taddei, Raphael's great friend, and finally the *Belle Jardinière*, dated 1508 (and not 1507 as was previously thought), probably painted for Filippo Sergardi of Siena. The theme of all these compositions is the Virgin and Child with the little Saint

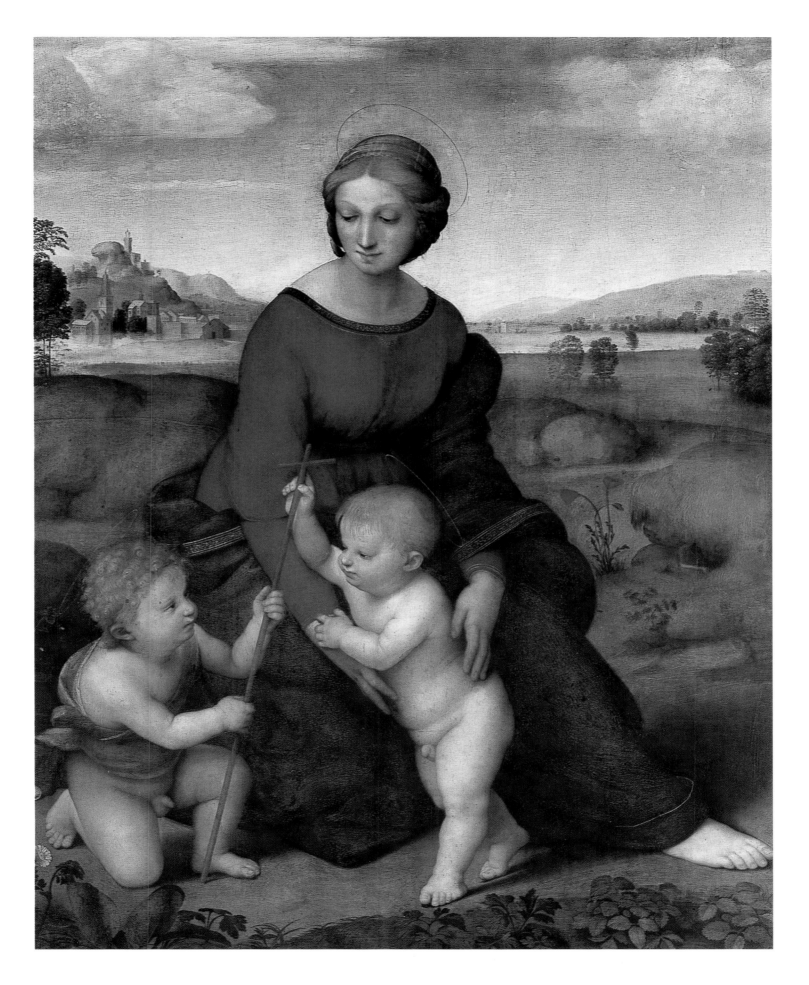

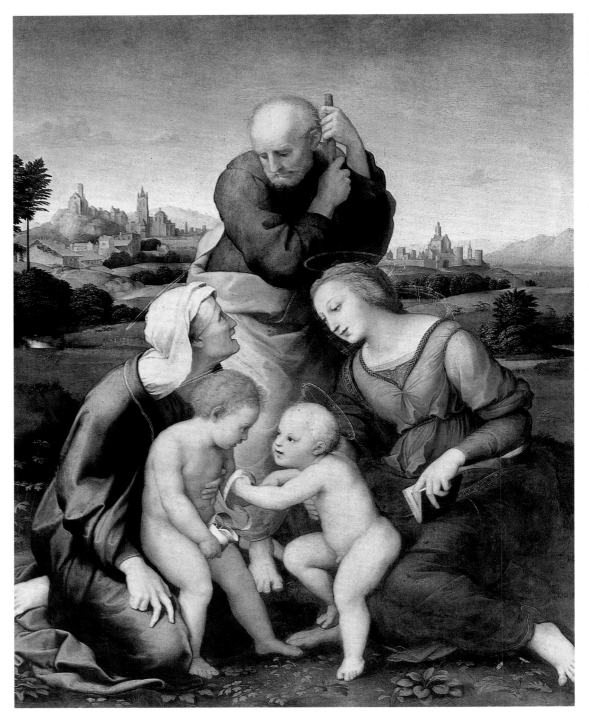

FOR THE WEDDING OF DOMENICO CANIGIANI
On the occasion of the wedding of the noble Domenico Canigiani to Lucrezia Frescobaldi, celebrated in 1507, Raphael painted the *Holy Family with Saint Elizabeth and Young Saint John* (Munich, Alte Pinakothek). The detail of the landscape on the facing page is extremely evocative. The work was probably painted for the wedding chamber or the family chapel in their Florentine palace, which is still standing in the Santo Spirito district. The Canigiani family was related to that of Lorenzo Nasi, who commissioned the *Madonna of the Goldfinch* (see p. 44).

John; all three are built up with the pyramidal figure masses used frequently by Leonardo. Another much-requested subject for the Florentine palaces was the Holy Family: examples include the tondo called the *Madonna della Palma* (Edinburgh, National Gallery), the *Holy Family with a Lamb* (Madrid, Prado), signed and dated 1507, an almost literal translation of certain of Leonardo's studies; and finally the *Holy Family* (today in the Alte Pinakothek of Munich) painted in 1507-1508 for Domenico Canigiani, Lorenzo Nasi's brother-in-law.

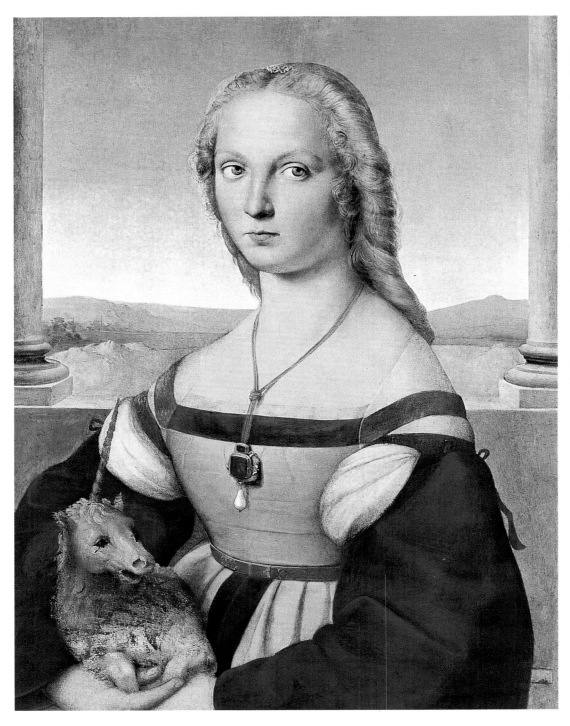

... AND THE UNICORN APPEARED
The *Portrait of a Woman with the Unicorn* (1505-1506; Rome, Borghese Gallery) is mentioned by the eighteenth-century cataloguers of the Roman collection as *Saint Catherine*; at that time, the hands were arranged differently, the figure was draped in a cloak and was accompanied by a broken wheel and the palm, the emblems of the martyrdom of the saint. An x-ray examination conducted in 1935 during restoration revealed that those portions had been added by a different hand; once eliminated, the original, and non-religious, aspect of the painting again came to light.

Uniting as he did the civil tradition of fifteenth-century Florentine art and the expressive naturalism of Leonardo, Raphael excelled in portraiture. He developed a formula that responded to the desire for strict character studies expressed by the Florentine "high society" of the times. In the *Woman with the Unicorn* (Rome, Galleria Borghese), in the *Portrait of Agnolo Doni* and that of *Maddalena Strozzi* (Florence, Galleria Palatina), in the *Portrait of a Woman* known as *La Gravida* (Florence, Galleria Palatina) and finally in the other *Portrait of a*

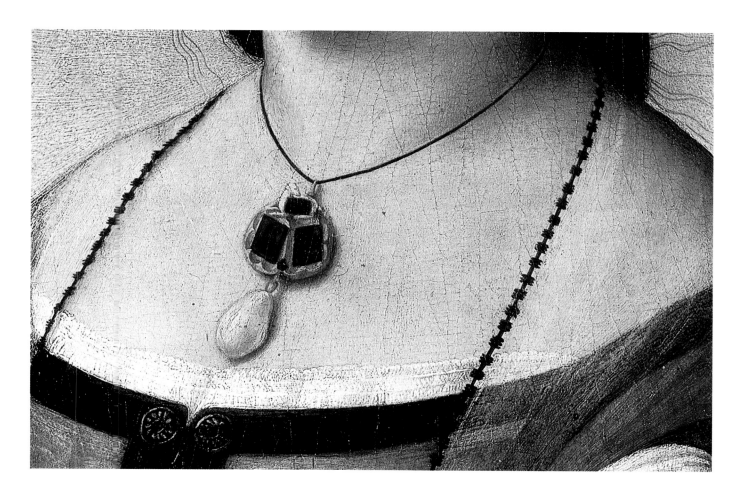

SYMBOLS OF CHASTITY
Like the unicorn
and the ornament
in the previous
painting, the jewel
in the detail of the
*Portrait of Magdalena
Strozzi* (1506;
Florence, Galleria
Palatina. See p. 48)
alludes to chastity.

Woman known as *La muta* (Urbino, Galleria Nazionale delle Marche), Raphael paid great attention to the pose (making use of the formula already tested by Leonardo in the *Mona Lisa*), the dignified, austere, silent and sometimes slightly melancholy expressions, and to scrupulously research into the costumes, the jewelry and everything else that could contribute to defining the status of the subject.

An interesting hypothesis has been advanced in regard of *The Mute Woman*, datable to 1507-1508, by which the subject would be Giovanna Feltria Della Rovere herself, the artist's devoted patroness in Urbino. In fact, even as he maintained a closely-woven network of relations in Florence, Raphael also continued to conduct frequent *extra moenia*; so much so that in the 1505 contract for the panel in Monteluce the artist states that he can be contacted in Perugia, Assisi, Gubbio, Rome, Siena, Florence, Urbino and Venice. Raphael also cultivated his by then stable relations with Perugia (where he leaned on the studio of Perugino or one or another of his followers) and with Urbino, perhaps keeping his father's studio open. He is mentioned as having been in Perugia twice in 1505; it is probable that at that time he completed the *Colonna Altarpiece* for the nuns of Sant'Antonio and paint-

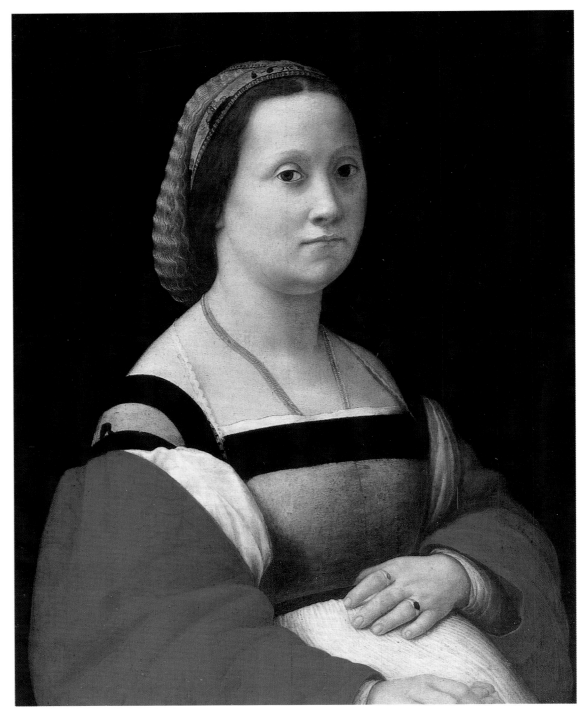

RENAISSANCE COSTUME
The *Portrait of a Woman* known since the early nineteenth century as *La Gravida* (1506-1507; Florence, Galleria Palatina) is practically contemporary to the portraits of Doni husband and wife or may slightly predate them. Like the latter paintings, this is a fascinating document of the costume of the period. On the facing page, a detail showing the bodice and sleeve and the necklace.

ed another for the Ansidei chapel in San Fiorenzo dei Serviti. In 1507 he was again in the Umbrian city for the *Baglioni Altarpiece* for the church of San Francesco al Prato, where the ancona of the Oddi family, the enemies of the Baglionis again in exile, had already been installed. It may have been at this time that the artist began the fresco of the *Holy Trinity* in San Severo, which was completed by Perugino in 1521.

While his altarpieces for the noble families of Perugia were still much after Perugino's style, for the court of Montefeltro Raphael in-

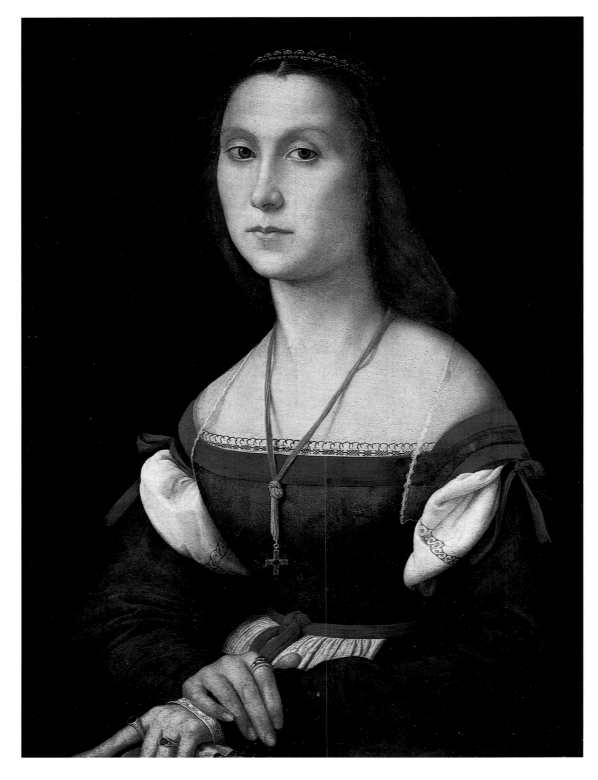

**GIOVANNA FELTRIA,
A DEVOTED CLIENT**
The portrait known as
The Mute Woman
(1507-1508; Urbino,
Galleria Nazionale
delle Marche)
may be a portrayal
of Giovanna Feltria,
sister of the duke of
Urbino Guidobaldo
da Montefeltro.
In 1504, Giovanna
Feltria wrote in her
own hand the letter
presenting Raphael
to the *gonfaloniere*
of Florence. It is
probable that
*Saint George Fighting
the Dragon* (1506;
Washington, National
Gallery of Art) was
commissioned by her
brother Guidobaldo.

stead produced small paintings in keeping with the exclusive, refined
literary culture that reigned there, with selected references to Flemish
art and to courtly poetry. The artist is reported as having been at the
Urbino court in 1505, in 1506 and in 1507; it was for Montefeltro that
he painted the *Portrait of Elisabetta Gonzaga* and that of her hus-
band, the duke *Guidobaldo da Montefeltro*, both in the Uffizi.

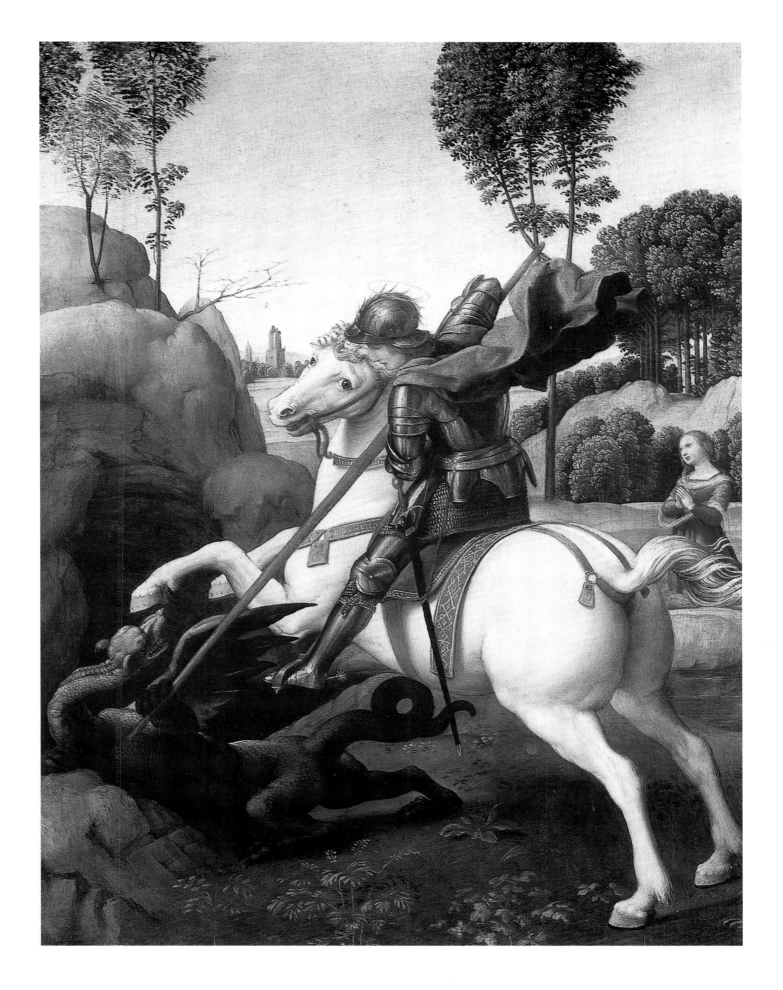

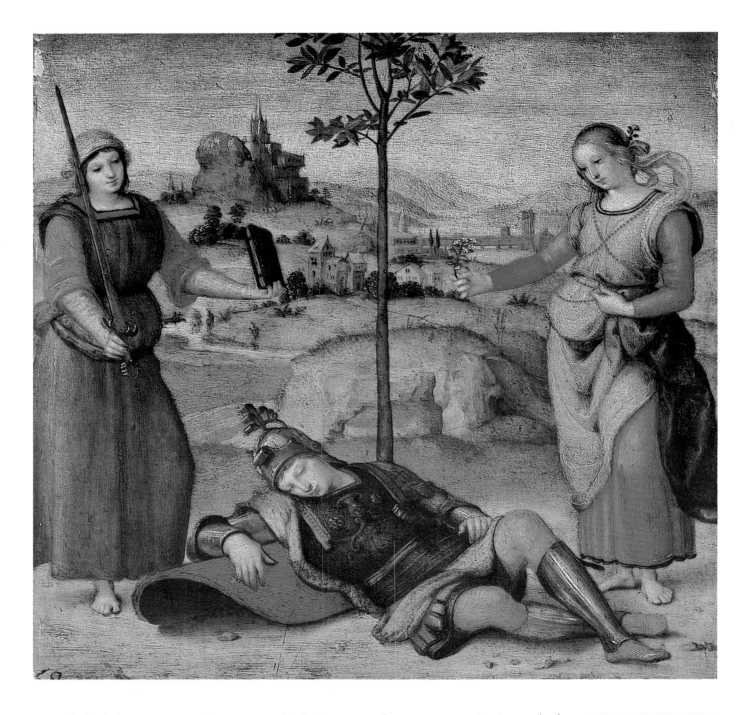

Guidobaldo's sister, Giovanna Feltria, may have commissioned the diptych with *Saint Michael* and *Saint George* (Paris, Louvre). The artist painted *Saint George Fighting the Dragon* (1506; Washington, National Gallery of Art) for Guidobaldo. It is instead uncertain who commissioned the small, refined diptych with the *Knight's Dream* (London, National Gallery) and the *Three Graces* (Chantilly, Musée Condé), although the theory has been advanced (Beguin, 1984) that it was painted in 1504-1505 for Francesco Maria Della Rovere, the son of Giovanna Feltria, portrayed by Raphael in the *Portrait of a Man with an Apple* (Florence, Uffizi).

'TWIXT VIRTUE AND PLEASURE
Taking its inspiration from ancient literary texts, *The Knight's Dream* (1504-1505; London, National Gallery) represents the choice between Pallas and Venus; that is, between Virtue and Pleasure.

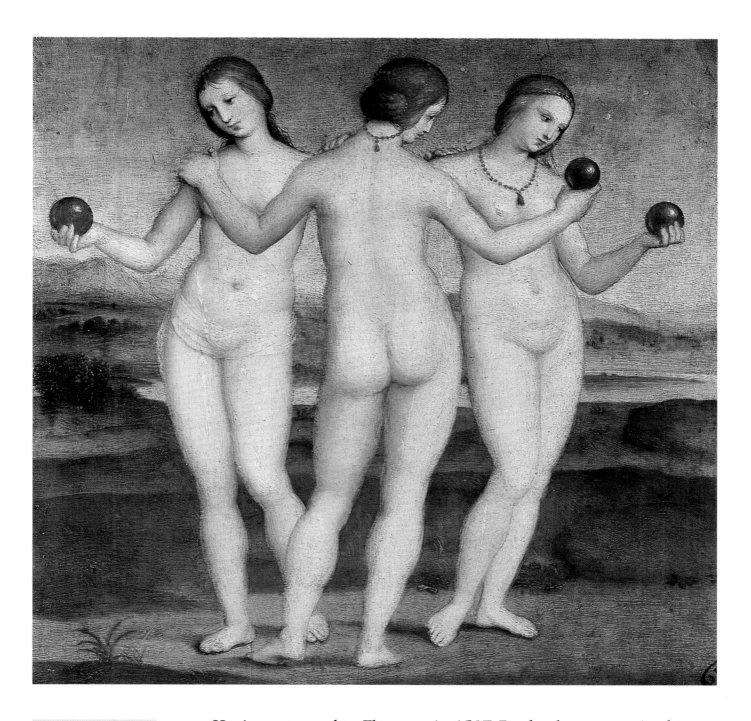

IMMORTAL FRUITS
Painted as a
companion to the
preceding painting,
the *Three Graces*
(1504-1505;
Chantilly, Musée
Condé) alludes
to immortality
with the mythical
golden apples
of the Hesperides.

Having returned to Florence in 1507, Raphael was surprised to receive a commission for an altarpiece: the *Dei Altarpiece* for Santo Spirito. But by that time, well aware of his qualities and his artistic maturity, he was setting his sights higher. Thus, on 21 April 1508, he wrote to his uncle Simone Ciarla asking him to procure a letter of presentation from Francesco Della Rovere, then the prefect of Rome, to the Florentine gonfaloniere requesting "a certain room to paint" in Palazzo Vecchio. But even while this avenue was revealing itself a dead end, much wider horizons were opening: Francesco Maria's uncle, Pope Julius II Della Rovere, summoned Raphael to Rome.

The Roman Period

It was certainly not the first time Raphael had been to Rome: one of the earliest was perhaps when, in 1502-1503, he was in Siena working with Pinturicchio; one of the last in 1506, on occasion of the discovery of the *Laocoon*. Raphael was asked by Donato Bramante, architect to the papal court, to express his opinion of the works submitted to the competition for the best waxen copy of the statue. Jacopo Sansovino was declared winner. The memory of the Hellenistic sculpture remained indelible in Raphael's receptive mind and from it there emerged the left-hand carrier in the *Borghese Deposition* and *Saint Catherine of Alexandria* (London, National Gallery). The attraction exerted by the papal city was enormous. Neither was Raphael lacking in acquaintances there; his fellow-countrymen Francesco Maria Della Rovere and Bramante were very close friends, and the support of the latter would seem to have been determinant in convincing Pope Julius II to call Raphael to his side. The season of the great commissions had arrived even for the young painter from Urbino, who had no qualms about leaving unfinished the Dei altarpiece in Florence or other works elsewhere, for example the *Esterhazy Madonna* (Budapest, Szépmüvészeti Muzeum). The dream was coming true and, in late 1508, Raphael was standing before the Pope. A fascinating man with a combative, sanguine and wilful character,

JUSTICE FRONT AND CENTER
The four allegorical portrayals of *Theology, Poetry, Philosophy* and *Justice* (shown below), are painted at the center of the ceiling of the Room of the Segnatura (1509; Vatican City, Vatican Palace).

FROM THE LAOCOÖN, A SAINT
The torsion of the female figure in *Saint Catherine of Alexandria* (London, National Gallery) is borrowed from Leonardo's *Leda*. But the expression of interior strength and grievous acceptance of her martyrdom derives from the *Laocoön*, the Hellenistic sculpture that Raphael had seen in Rome in 1506-1507

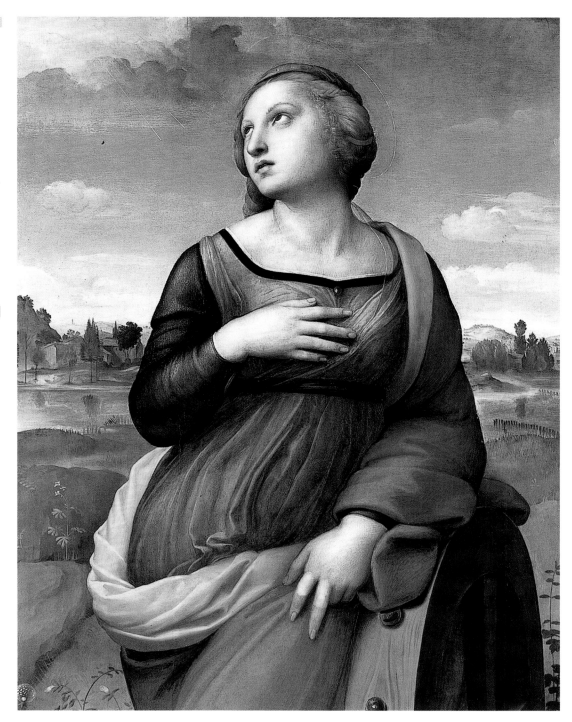

Julius II had some time earlier decided to decorate the rooms on the upper floor of the papal palace, stating that he would never have lived in the apartment of that "faithless, iniquitous cad" who was his predecessor Alexander VI Borgia. A number of artists, including Perugino, Sodoma e Lotto, had been working for some months in the rooms selected by Julius II, but they were immediately dismissed when the pope saw the first samples offered by Raphael, whom he appointed "*scriptor brevium*" and court painter. Meanwhile, in the nearby Sistine

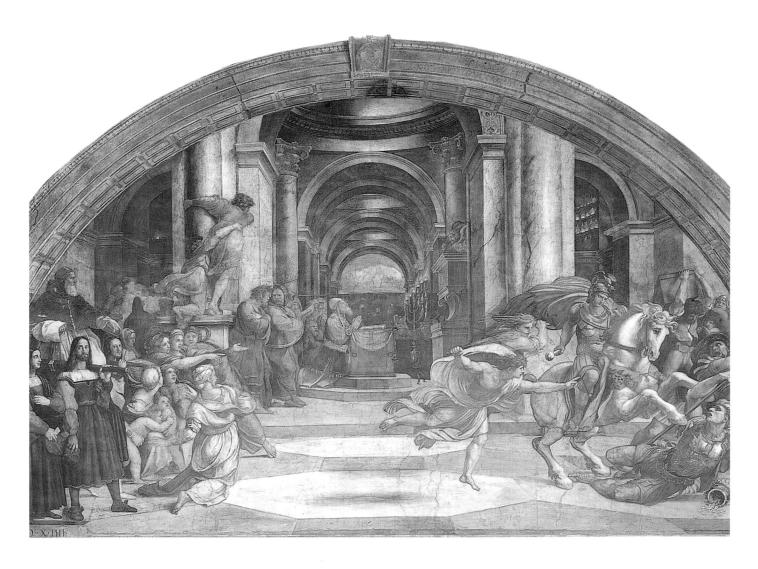

Chapel, Michelangelo had begun working on the decoration of the ceiling, alone and forbidding anyone to enter.

On 13 January 1509, Raphael received his first payment "*ad bonum computum picturae camerae*". In fact, he had begun painting the first room for Julius II, destined to contain the papal library (now known as the Room of the Segnatura because it was later transformed into the seat of the *Signatura Gratiae* tribunal) immediately upon his arrival in Rome. The theme underlying the decoration as a whole – perhaps suggested by the learned Paolo Giovio – was the representation of truth, good, and beauty: Truth revealed, or theology (the *Dispute of the Blessed Sacrament*) contrasted with rational truth (the *School of Athens*), moral Good (the *Cardinal Virtues*) accompanied by civil and canonical Good (*Tribonian Delivering the Pandects to Justinian* and *Gregory IX Approving the Decretals*), and finally Beauty, identified in poetry, with its apotheosis in the *Parnassus*. In 1511, the room was completed and thoughts immediately turned to decorating

THE THIEF OUSTED FROM THE TEMPLE
The *Expulsion of Heliodorus from the Temple* (1512; Vatican City, Vatican Palace, Room of Heliodorus) taken from the Old Testament illustrates the moment in which the divine messenger answers the prayer of the priest and drives the thief from the temple. Pope Julius II watches the scene from the left.

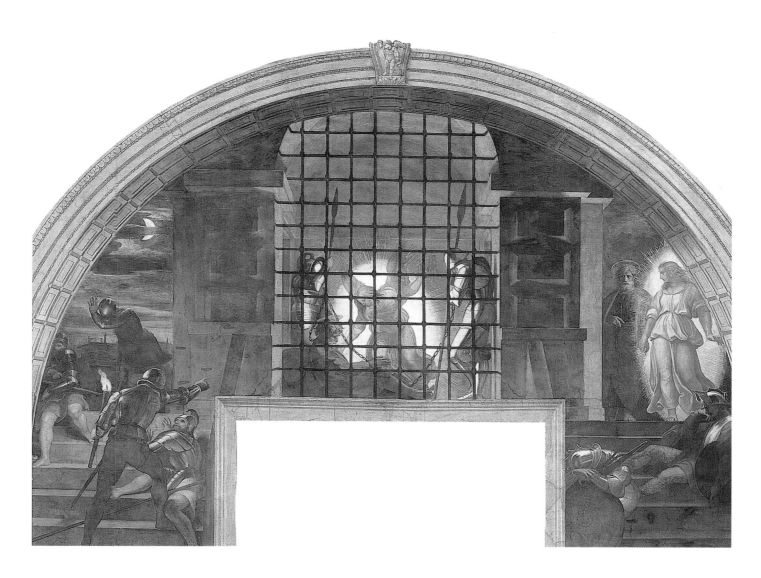

the next, the audience room or the Room of Heliodorus. The pope, involved in a harsh conflict with France, inclined more and more toward themes celebrating the invincibility of the power – both theological and temporal – of the papacy sustained by the supernatural support of God. From the generalized allegories and the symbolic images of the first room, Raphael thus went on to representing emblematic historical facts: the *Expulsion of Heliodorus from the Temple*, the *Miracle at Bolsena*, the *Liberation of Saint Peter*, based on the *Acts of the Apostles*, and finally *Leo I Halting Attila*.

In this scene, painted in 1514, Leo the Great is the portrait of the new Pope Leo X, the former Cardinal Giovanni de' Medici, son of Lorenzo il Magnifico, elected following the death of Julius II on 11 March 1513. The new pope, as befitted one of his family, was an educated man interested in theological studies, poetry and music – and in antiquities, of which he named Raphael curator in 1515. Although he had Raphael continue the decoration of the rooms, Leo X also entrust-

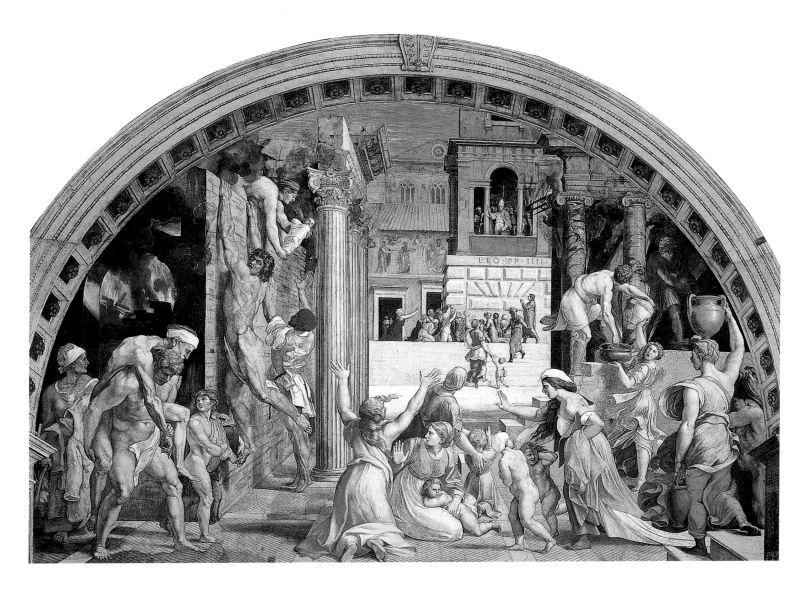

ed him with a great number of other tasks; the artist, in turn, made increasing use of his team of assistants, each of whom was specialized in a certain figurative genre. The next room (formerly known as the Borgia Tower), with its ceiling decorated by Perugino and at the time of Julius II the seat of the *Signatura Gratiae,* became the dining hall in which the new pope held sumptuous banquets with the cardinals. The general cast of the cycle of frescoes is clearly eulogistic; it represents episodes in which Leo IV and Leo III, predecessors of the Medici pope and his name-givers, were the illustrious protagonists. Among the scenes painted here, the most important is perhaps *The Borgo Fire in A.D. 847,* which gives the room its name. Its highly theatrical cast recalls the ephemeral scenic installations in the Rome of the time, some of which are attributable to Raphael himself.

When this *stanza* was completed in 1517, Leo X commissioned Raphael to paint the last one as well – the so-called Hall of Constan-

THE FIRE IN THE BORGO
The fire that raged in the Roman district of Borgo in 847, under Pope Leo IV, is remembered as an event as tragic as the burning of Troy. In *The Borgo Fire in A.D. 847* (1514; Vatican City, Vatican Palace), Raphael includes a group of Aeneas, Anchises and Ascanius fleeing the fire. In the detail on the facing page, Pope Leo IV watches the scene.

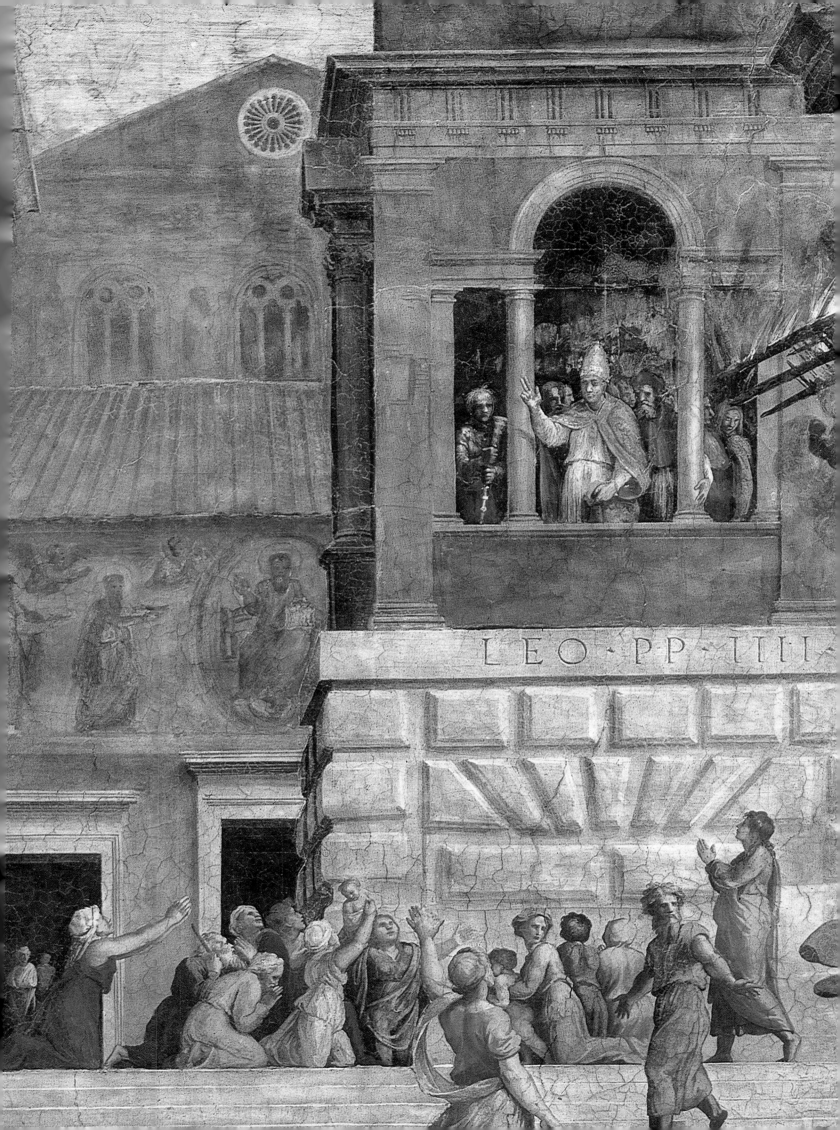

LEO · PP · IIII

tine. But the decoration was executed only after the master's death by Giulio Romano and Raphael's other collaborators. By that time Raphael was weighed down with innumerable commitments (at the death of Bramante, in 1514, he had added the title of Architect of Saint Peter's Basilica to his many designations); the pope's interest was also largely directed elsewhere. For example, to completion of the Sistine Chapel, after Michelangelo had frescoed the ceiling with episodes from the book of *Genesis*, the *Sibyls*, the *Prophets* and the *Ancestors*, in late 1514 Leo X commissioned Raphael to produce the cartoons for the tapestries representing the *Acts of the Apostles*, to be placed under the *Scenes from the Lives of Moses and Christ,* painted in the late fifteenth century, as their direct historical continuation.

In 1519 (the year preceding Raphael's death), while the tapestries created by Pieter van Aelst's workshop were on their way to Rome from Brussels, Raphael had taken on the tasks of drawing up an archaeological map of ancient Rome and monitoring the state of the classical monuments. With the aid of his friend Baldassare Castiglione he draft-

MICHELANGELESQUE SIBYLS
In about 1514, Raphael was requested to supply the designs for the exterior of the arch of the Chigi chapel in Santa Maria della Pace.
In the work, the *Sibyls* in particular would seem to be fruit of meditation on Michelangelo's *Sibyls* in the ceiling of the Sistine Chapel.

ed the report of that work as *ante litteram* Superintendent in a letter to Leo X. Also in that fateful 1519, the artist's collaborators completed the decoration of the Raphael Loggia in the Vatican, on the same floor as the rooms, with its two orders built by Bramante and the third by Raphael himself, as architect. And it was again Raphael, as Vasari tells us, who "prepared the designs for the stucco ornaments and the scenes painted there, as well as of the borders", but like any modern-day impresario and manager he had delegated the execution of the work to his well-organized studio: "Certainly no finer work can be conceived, [and] it led to Raphael's appointment as superintendent of all works of painting and architecture done in the palace".

In the meantime, in that same palace, the artist's privileged position in the papal court had offered him the opportunity to make the acquaintance of and indeed become intimate with the most influential figures in the Rome of Julius II and Leone X. One of these men was the Sienese banker Agostino Chigi, who owned a suburban villa in Trastevere (today's Villa Farnesina). In 1511, Chigi asked Raphael to paint the *Triumph of Galatea* on the ground floor of the residence on the Tiber, in a room in which the Venetian painter Sebastiano del Piombo had already worked. Chigi must have been pleased with the result, since he turned again to Raphael for decorating the chapels that had been donated to him by his friend Julius II in the two churches built by his uncle Sixtus IV, Santa Maria del Popolo and Santa Maria della Pace. Thus, in about 1514, Raphael frescoed the arch of the Chigi chapel in Santa Maria della Pace with sibyls, angels and prophets, and in 1516 he saw to decorating the other private chapel in Santa Maria del Popolo. The following year Raphael was again at Villa Chigi, directing his workshop as his collaborators decorated the loggia opening on the garden with scenes inspired by the *Tale of Cupid and Psyche*

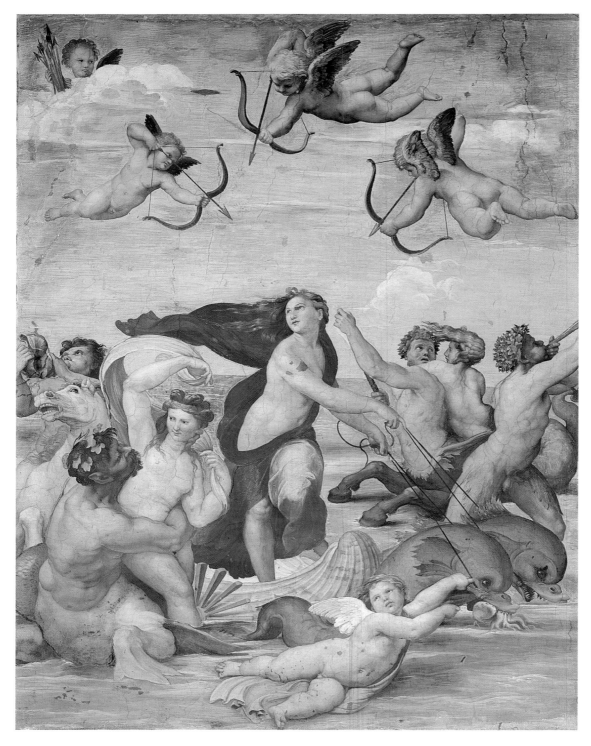

POLYPHEMUS AND GALATEA FOR THE POPE'S BANKER
The wealthy and noble Sienese banker Agostino Chigi asked Raphael to paint a fresco of the *Triumph of Galatea* in his villa on the Tiber (1511; Rome, Villa la Farnesina) on the wall on which the Venetian Sebastiano del Piombo was already painting a *Polyphemus*, the giant vainly enamoured of the beautiful nymph Galatea. On the facing page, a detail of the fresco.

from the Apuleius' *Golden Ass*. While he was working on the *Triumph of Galatea*, Raphael also painted the fresco of the *Prophet Isaiah* in Sant'Agostino for the apostolic protonotary Giovanni Goritz. Here, as in the Villa Chigi decorations, Raphael's painting makes explicit reference to Michelangelo, who in 1512 had uncovered the ceiling of the Sistine Chapel (at which, as Vasari tells us, Raphael had already sneaked a look, Bramante having the keys to the chapel).

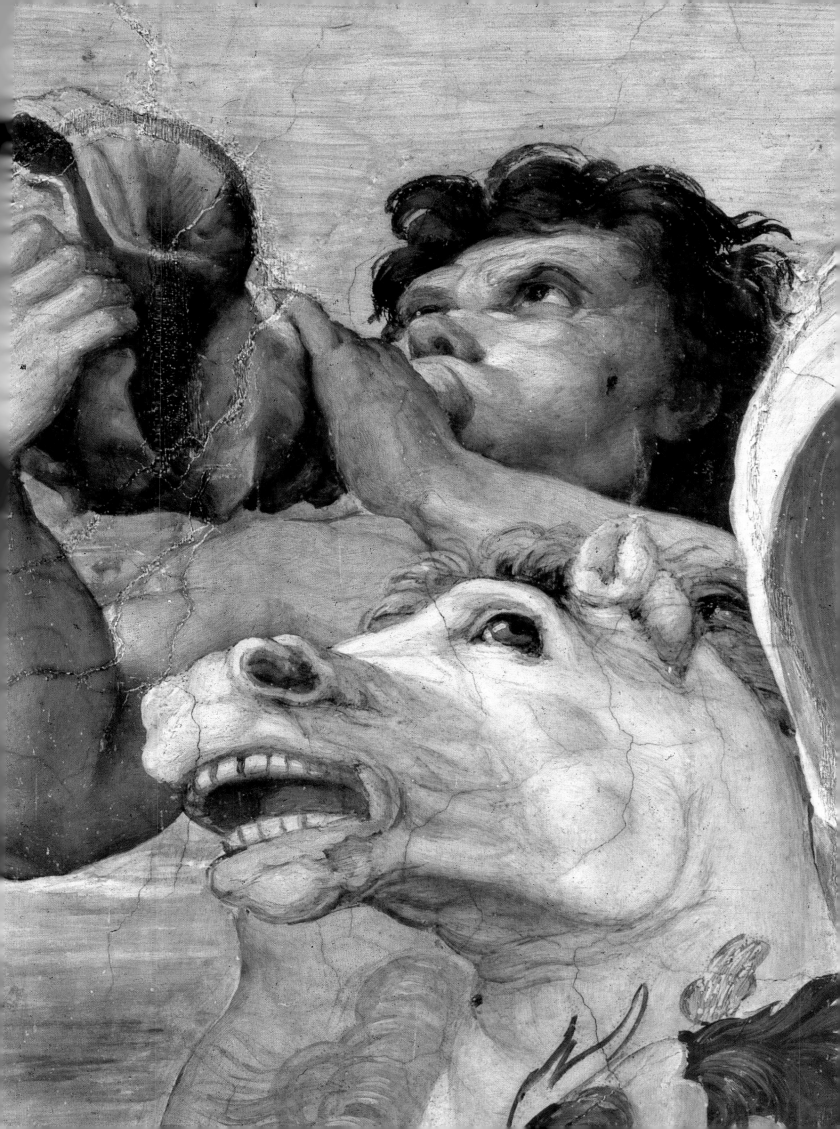

Among the habitués of the papal court, Cardinal Bibbiena was one of the Raphael's most devoted admirers; besides painting his portrait (now in Florence's Galleria Palatina), the artist decorated a number of rooms in the Cardinal's apartment in the Vatican. Raphael's celebrated Madonnas were created for private clients; as time went on this branch of his activity was more and more delegated to his collaborators. The *Madonna of the Aldobrandini* (London, National Gallery), the *Alba Madonna* (Washington, National Gallery of Art) for Paolo Giovio, who had it sent to his episcopal seat of the church of the Olivetani in Nocera dei Pagani, and the *Madonna of Loreto* (Chantilly, Musée Condé) for Julius II were all painted during Raphael's early Roman period, when Julius II was pope. The *Madonna della Seggiola* (Florence, Galleria Palatina) and its companion, the *Madonna della Tenda* (Munich, Alte Pinakothek) instead date to the first years of Leo X's pontificate. Only a little later came the *Madonna dell'Impannata* (Florence, Galleria Palatina), painted for the young banker and legate of the Roman curia Bindo Altoviti, who sent the painting to his home in Florence. Finally, the *Holy Family* (Paris, Louvre), dated 1518, was commissioned of Raphael by Leo X himself, who presented it, together with *Saint Michael Fighting the Devil* (Paris, Louvre) to Francis I King of France.

Certain of those who commissioned these paintings – including even popes Julius II and Leo X – also had their portraits painted by Raphael in works that had little to do with officialdom. Usually, when he portrayed subjects he knew well and with whom he had close rela-

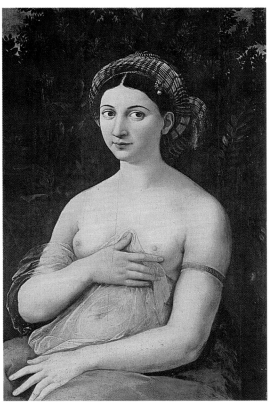

tionships, Raphael created intimately-informed and sometimes even affectionate images in which he not only illustrated their physical aspects but also provided insights into their personalities. Thus Raphael painted the elegant *Portrait of a Cardinal* (Madrid, Prado), perhaps the wicked Cardinal Francesco Aldoisi, and the roguishly winking *Cardinal Dovizi Bibbiena* (Florence, Galleria Palatina); the empathetic portrait of his friend and fellow-countryman *Baldassare Castiglione* (Paris, Louvre) and the homely image of *Tommaso Inghirami*, also known as *Fedra* (Florence, Galleria Palatina), in 1510 the prefect of the Vatican Library; and the fascinating *Bindo Altoviti* (Washington, National Gallery of Art) in all the elegance of his youth. And there is more: a pronounced individuality in an intimate atmosphere in the portrait known as *La Donna Velata* (Florence, Galleria Palatina) and the *Portrait of the Fornarina* (Rome, Barberini Palace), both probably portraits of Margherita Luti, the Sienese baker's daughter who Raphael loved and often used as a model; and finally the spontaneity of gesture, the communicative expressions and the sense of human dignity in the *Portrait of Navagero and Beazzano* (Rome, Galleria Doria Pamphili) and the *Portrait of the Artist with a Friend* (Paris, Louvre).

In those of the many portraits painted over the years which can be with certainly attributed to Raphael's hand alone, it is evident how

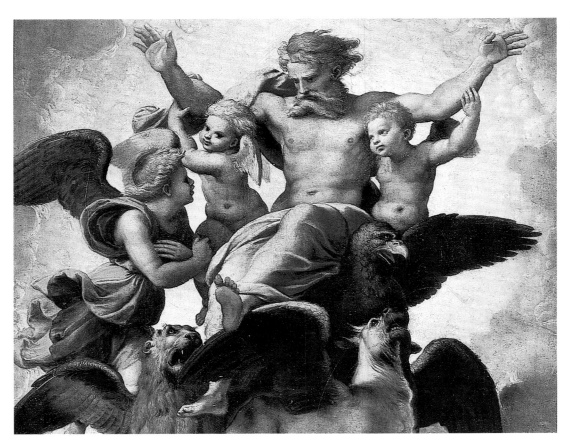

A GOD LIKE JOVE IN THE HEAVENS
The small painting represents the *Vision of Ezekiel* (detail; 1516; Florence, Galleria Palatina) described in the Old Testament book of the same name and in John's *Apocalypse*. The heavenly Father as described by Vasari appears "as Jove, in heaven" amidst the brilliantly lighted clouds, with cherubim the symbols of the evangelists. On pages 40-41, detail from the *School of Athens* (1509-1511; see p. 54-55)

the artist attempted to imbue his subjects with an ever-increasing emotional charge designed to establish an increasingly direct relationship with the viewer. This research into expressiveness and communicative capacity went hand in hand with an accentuation of the theatricality and scenic effects used in the frescoes of the rooms and with the evolution of the conception of the altarpiece. In the *Madonna di Foligno* (Vatican City, Pinacoteca), which on the whole follows the traditional scheme of the devotional altar paintings, we already notice a more subjective relationship among the characters and between the characters and the viewer. The panel was installed on the high altar of Santa Maria in Aracoeli, where Sigismondo de' Conti, who commissioned the work, was buried in 1512. Painted on canvas like a processional banner and conceived as an apparition approaching the faithful, instead, is the *Sistine Madonna* (Dresden, Gemäldegalerie), executed in 1514 by request of Julius II for San Sisto in Piacenza, where the relics of Saint Sixtus II, the patron of the Della Rovere family, were preserved. Sole protagonists are instead the saints in the *Santa Cecilia* (Bologna, Pinacoteca Nazionale) commissioned for the church of San Giovanni in Monte Uliveto by Elena Duglioli dall'Olio through Antonio Pucci, Florentine prelate and intimate acquaintance of Leo X.

RAPHAEL ARCHITECT
An important part of Raphael's work during the pontificate of Leo X consisted of architectural activity. In 1519, as the end of his life was nearing, Raphael designed the villa of Cardinal Giulio de' Medici, who also commissioned the *Transfiguration* (see p. 60). Raphael, who did not live to see the building finished, explained in a letter that his plans were inspired by different of the ancient Roman villas.

Raphael's acquaintance with the sublime later on became an ecstatic vision, the miraculous transfiguration of the divine that we see in the altarpiece, for which the small *Vision of Ezekiel* (Florence, Galleria Palatina) would seem to have provided the premise, ordered by Cardinal Giulio de' Medici in 1516 for the cathedral of Narbonne. This work marks the end of an itinerary along which Raphael so profoundly renewed the very conception of the altarpiece and of devotional painting as to much anticipate the time of the Counter-Reformation.

That extraordinary adventure that had been the life of Raffaello Sanzio ended on 6 April 1520. He was already a myth among his contemporaries, and his myth was enlarged upon by posterity. There were even observed supernatural signs that led people to compare the death of Raphael to that of Christ.

Giulio Romano, Giovan Francesco Penni, Giovanni da Udine, Perin del Vaga and Polidoro da Caravaggio were among those who completed the numerous commissions begun by their impresario, including the *Monteluce Altarpiece* ordered way back in 1501-1503 by the good sisters of Perugia. Raphael's team disbanded in 1527 when the artists fled to various cities to escape the Sack of Rome: everywhere they carried with them their master's manner, to Mantua, to Genoa, and to Naples.

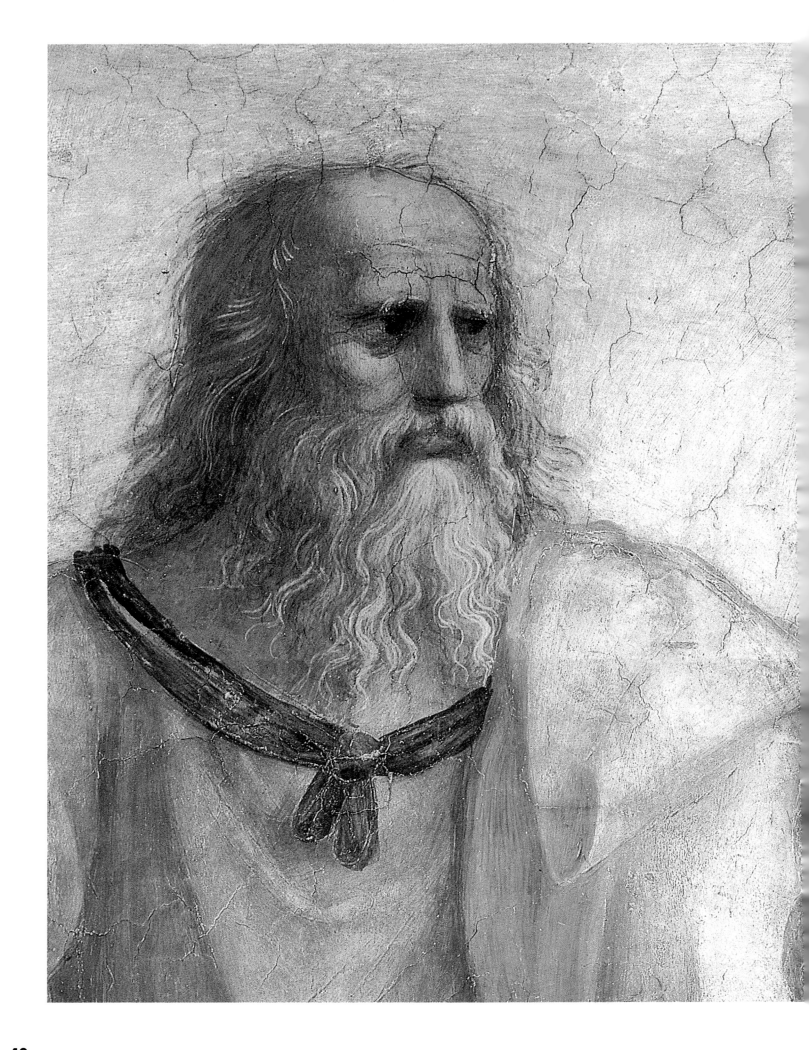

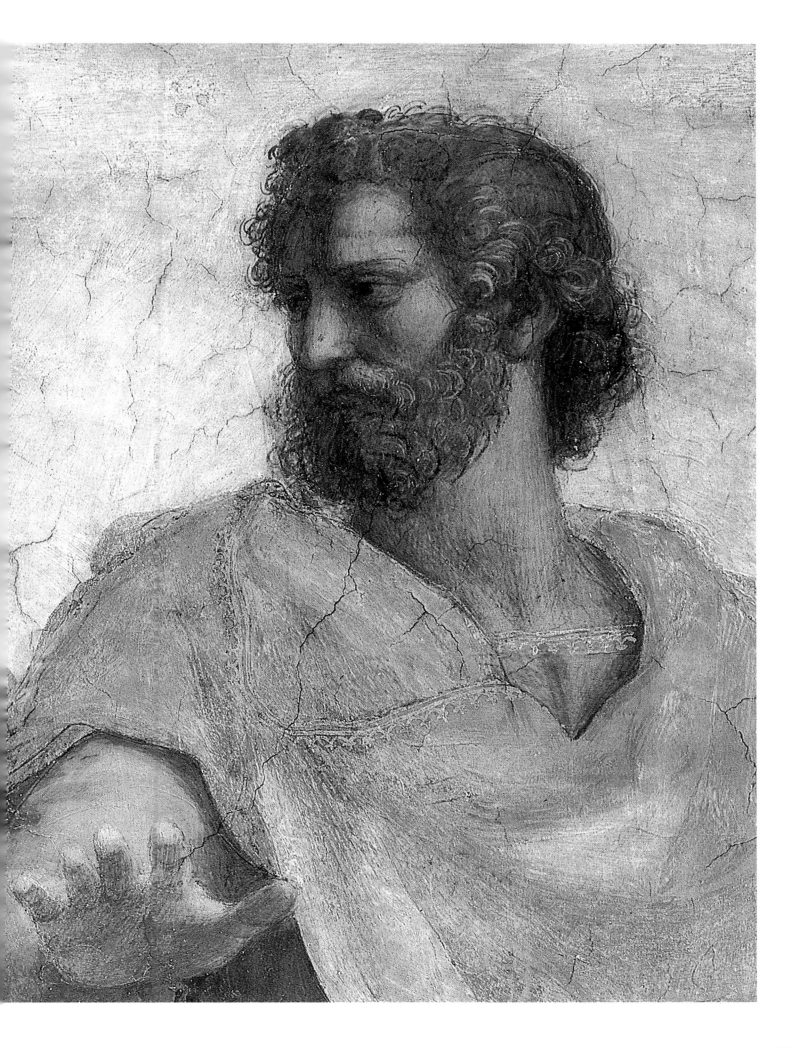

THE MARRIAGE OF THE VIRGIN

While he was painting the altarpiece, Raphael most certainly had in mind two paintings by Perugino: the *Giving of the Keys to St. Peter* in the Sistine Chapel (1482) and above all the later *Marriage of the Virgin* (Caen, Musée des Beaux Arts) painted in 1503-1504 for the cathedral of Perugia. With respect to both of these works, however, Raphael's painting shows substantial differences that bespeak a new manner of conceiving space: first of all, the temple is shown in full and without the truncated cupola; the form is almost circular thanks to the doubling of the sides from eight to sixteen and the introduction of a surrounding portico in which small figures move; the figures in the foreground are arranged in two tangent semicircles – one opening toward the temple, the other toward the viewer – with the figure of the priest in common. This conception reflects the lessons imparted by Piero della Francesca and the architects of the latter half of the fifteenth century in the ducal palace of Urbino.

The Marriage of the Virgin
oil on wood
170 x 117 cm; 1504
Milan, Pinacoteca di Brera

DATED AND SIGNED
The signature on the entablature of the portico reads "Raphael Urbinas" (Raphael of Urbino); the date "MDIIII" (1504) is inscribed at the sides of the center arch. The work was ordered by the Albizzini family for the chapel of San Giuseppe in the church of San Francesco in Città di Castello.

A COLLEAGUE IN ARCHITECTURE
Raphael's work is intoned as to both intentions and results with that of Donato Bramante, from Urbino like himself. The building in the Brera painting replicates the architecture of the *Tempietto* of San Pietro in Montorio in Rome, designed by Bramante in about 1504 (shown below in a drawing in the Uffizi collection).

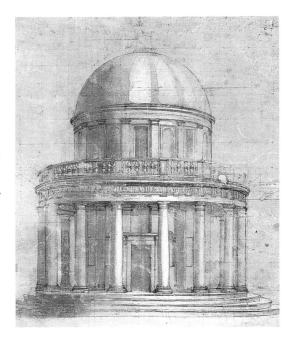

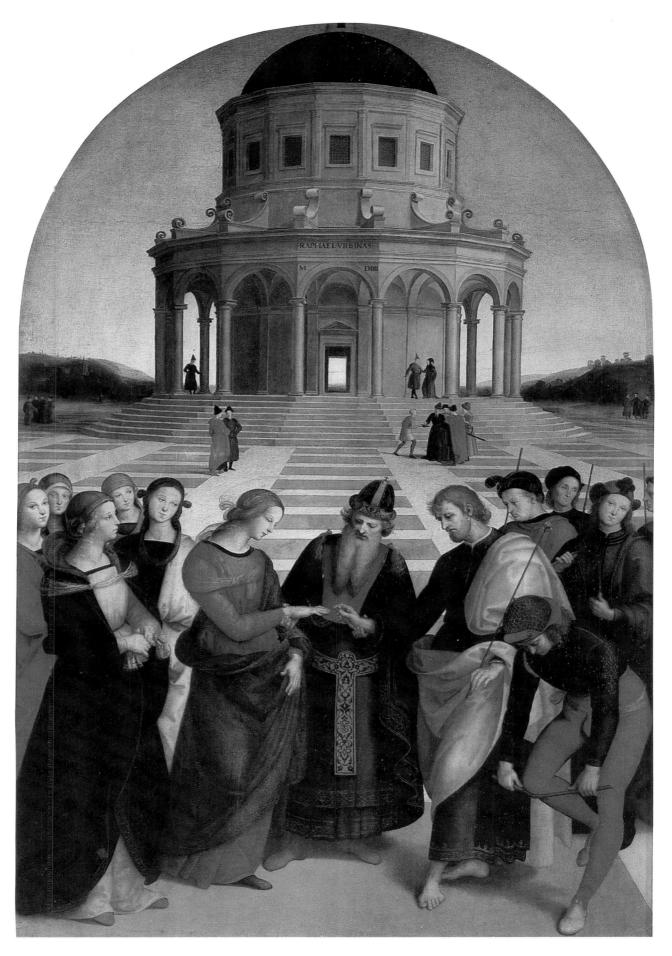

THE MADONNA OF THE GOLDFINCH

The painting was commissioned of Raphael by the Florentine Lorenzo Nasi, of a family of wealthy merchants, who lived in Via de' Bardi across from Palazzo Canigiani. Matteo Canigiani's daughter Sandra married Nasi in 1505 (or at the latest by 23 February 1506). Raphael painted the *Madonna of the Goldfinch* around that time, and he relied on two exceptional sources: Leonardo, for the pyramidal arrangement of the figures that recalls the *Virgin of the Rocks* (Paris, Louvre), and Michelangelo. Unfortunately, the *Madonna of the Goldfinch* was severely damaged when the Nasi home collapsed on 17 November 1548.

Nasi's son Giovambattista restored the painting: recent x-rays (1972, 1983) of the work have revealed the presence of seventeen discreet pieces held together by long nails placed transversely and integrated by three plugs and a large insert, and relative repainting. This state of affairs, by now of centuries' standing, has so far discouraged cleaning and restoration of the work.

The Madonna of the Goldfinch
oil on wood
107 x 77 cm; 1505-1506
Florence, Uffizi

VASARI'S OPINION
The *Madonna of the Goldfinch* is one of Raphael's Florentine works most esteemed by Vasari: "Raphael was also very friendly with Lorenzo Nasi, and as Lorenzo had newly taken a wife, he painted him a picture of a babe between the knees of the Virgin, to whom a little St. John is offering a bird, to the delight of both".

MICHELANGELO'S MOTIFS AS INSPIRATION
One of the most evident sources of inspiration for the *Madonna of the Goldfinch* is to be found in Michelangelo's work, and precisely in the *Madonna of Bruges* (below), where the Child rests His foot on that of the Virgin. Michelangelo sculpted this work between 1504 and 1506 (Bruges, Church of Notre Dame).

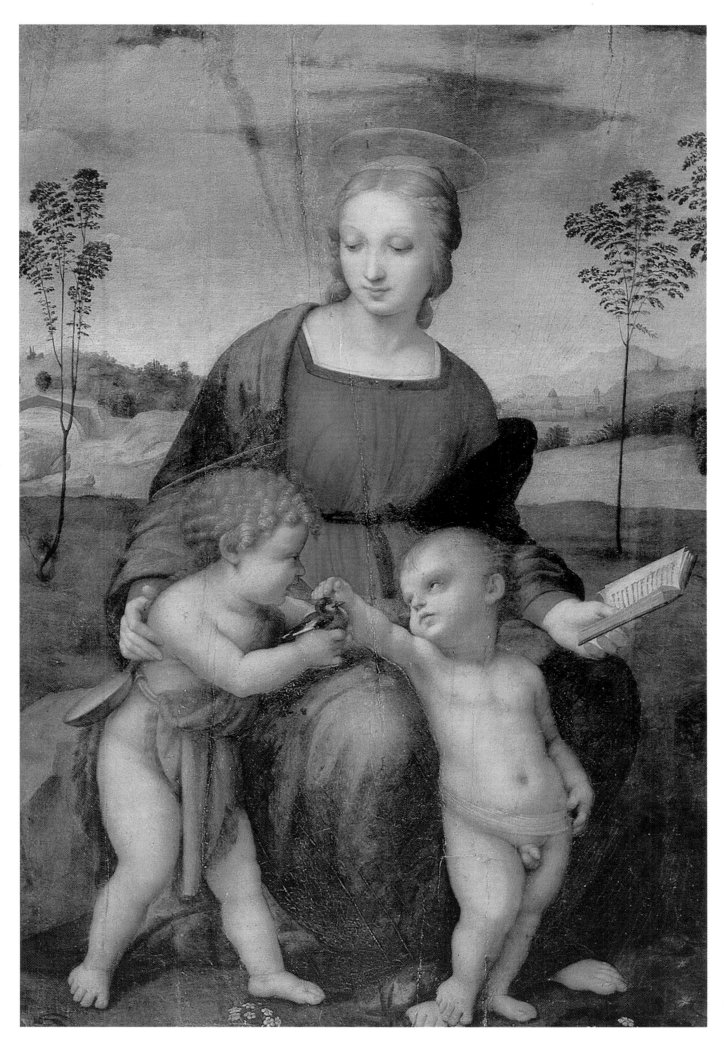

THE GRAND-DUKE'S MADONNA

The first mention of this painting dates to 23 November 1799, when the then Director of the Uffizi, Tommaso Puccini, brought it to the attention of Grand Duke Ferdinand of Lorraine. Ferdinand was in Vienna at the time; it was there that he received Puccini's letter recounting how he had seen at a "Florentine merchant's" a "well-preserved" work "in the manner of Raphael of Urbino", and requested authorization to purchase it. Since the French despoilers had in the meantime deprived Palazzo Pitti of its precious paintings, Ferdinand II did not hesitate to authorize the acquisition. The original destination of the work is unknown; it was most certainly a private commission. The work may be dated to about 1506 thanks to the *sfumato* reminiscent of Leonardo and the composed tenderness the embrace of Mother and Son. The simple and harmonious composition has often been compared with the more complex *Madonna della Seggiola*.

The Grand-Duke's Madonna
oil on wood
84.4 x 55.9 cm; ca. 1506
Florence, Galleria Palatina

A PERSONAL MADONNA
Ferdinand III, who had commissioned the purchase, was so impressed by the painting when he saw it that he wanted it with him in his exile in Würzburg. When he returned to Florence he placed it in his bedroom. Thus the painting acquired the name by which it is generally known: the *Grand-Duke's Madonna*.

THE LOST LANDSCAPE
X-ray investigation has revealed a quite different background under the black film of paint. The drawing below (Florence, Uffizi) also provides evidence that Raphael had originally planned the composition as a tondo and with a landscape in the background.

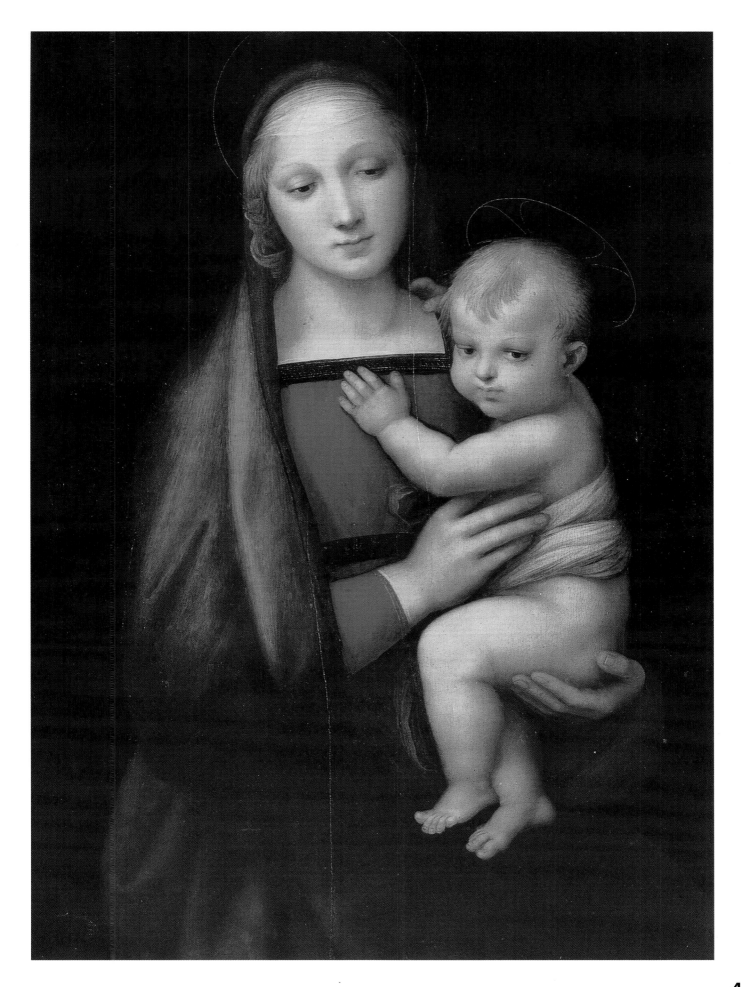

PORTRAIT OF AGNOLO DONI

The painting portrays Agnolo Doni (Florence, 1474-1539), a wealthy wool merchant who in 1504 married Maddalena Strozzi. Agnolo was one of the most intelligent and munificent patrons of the arts in the early Florentine Cinquecento: he collected antiquities and gems and commissioned paintings of Michelangelo (the *Doni Tondo* in the Uffizi) and Fra' Bartolomeo (the *Holy Family with Young Saint John*; Rome, Galleria Corsini). The *Amore-Atys* by Donatello (now in Florence, Bargello) was probably among the works owned by Agnolo. In the portrait, the high social status and the refined and exclusive culture of the subject are indicated above all by the clothing, which is elegant and precious both in its materials and in its cut without, however, becoming ostentatious. On the verso of the portrait of Doni and its companion *Portrait of Maddalena Strozzi* are two monochromes by an anonymous artist depicting scenes from the myth of *Deucalion and Pyrrha* (verso of Agnolo) and the *Rebirth of Humankind* (verso of Maddalena).

Portrait of Agnolo Doni
oil on wood, 65 x 45.7 cm; 1506-1507
Florence, Galleria Palatina

SYMBOLS OF MARRIAGE
The precious pendant worn by Maddalena is composed of a unicorn (symbol of chastity), an emerald (with thaumaturgical powers), a ruby (sign of power and prosperity), a sapphire (emblem of purity) and finally a pearl (alluding to virginity).

PRESTIGIOUS GIFTS
The jewel worn by Maddalena Strozzi in the portrait in Florence's Galleria Palatina, the companion painting to the *Portrait of Agnolo Doni*, may be the same jewel given by Agnolo to his wife as a wedding present.

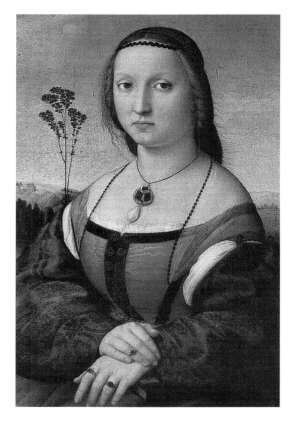

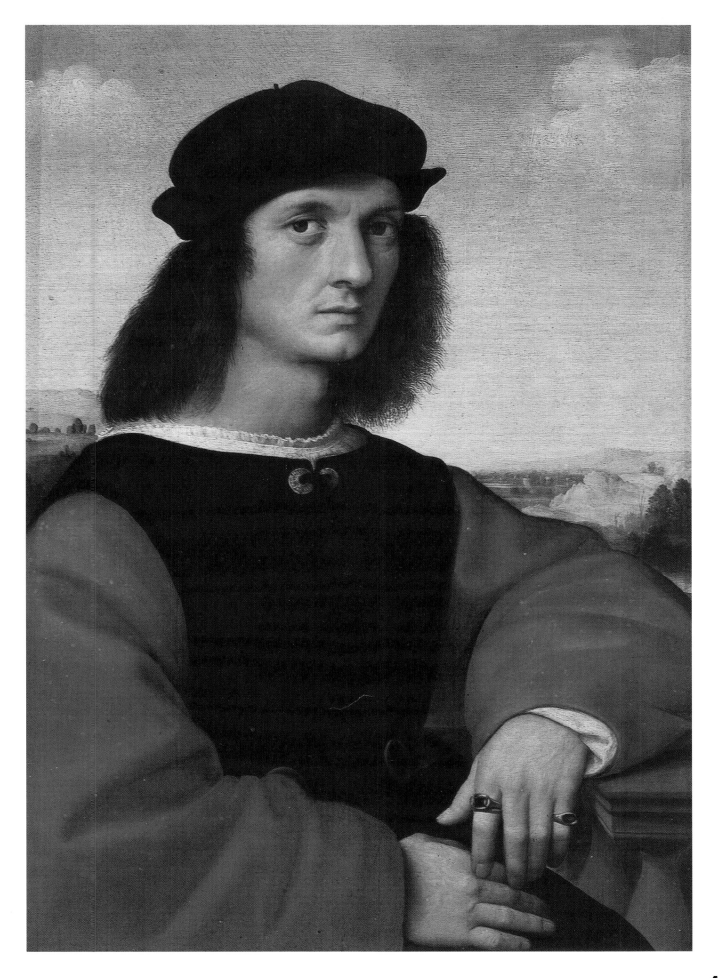

THE ENTOMBMENT OF CHRIST

T he work was originally accompanied by a cyma with the *Eternal Father and Angels*, now lost, and by the predella of the *Theological Virtues*, now in the Pinacoteca Vaticana. The *Entombment of Christ* is signed and dated with the inscription "RAPHAEL URBINAS MDVII". Atalanta Baglioni commissioned the altarpiece for the family chapel in San Francesco al Prato in Perugia. Atalanta desired a work recalling her sorrow for the death of her son Grifonetto in July of the year 1500 during the struggle for control of Perugia; it was therefore important that the drama of the Virgin be represented. Raphael had at first imagined the composition as a sort of *Pietà* with Christ lying on the ground, his head on the knees of the Virgin, but he transformed the subject in accordance with Atalanta's wishes: during the long and difficult process, the figure of young man at the center, leaning toward the right in the same direction as the body of the Mother of Christ, became a fundamental element of union.

The Entombment of Christ
(Borghese Deposition)
oil on wood, 148 x 176 cm; 1507
Rome, Galleria Borghese

PREPARATORY SKETCHES
Two drawings (below), today in the Ashmolean Museum in Oxford, provide evidence of the complex series of studies and the changes of mind that went into the composition of the groups of figures.

CLASSICAL REFERENCES
There is no lack of references to classical motifs in the panel: that to the *Laocoon*, discovered in 1516 in Rome, is evident in the older carrier on the far left.

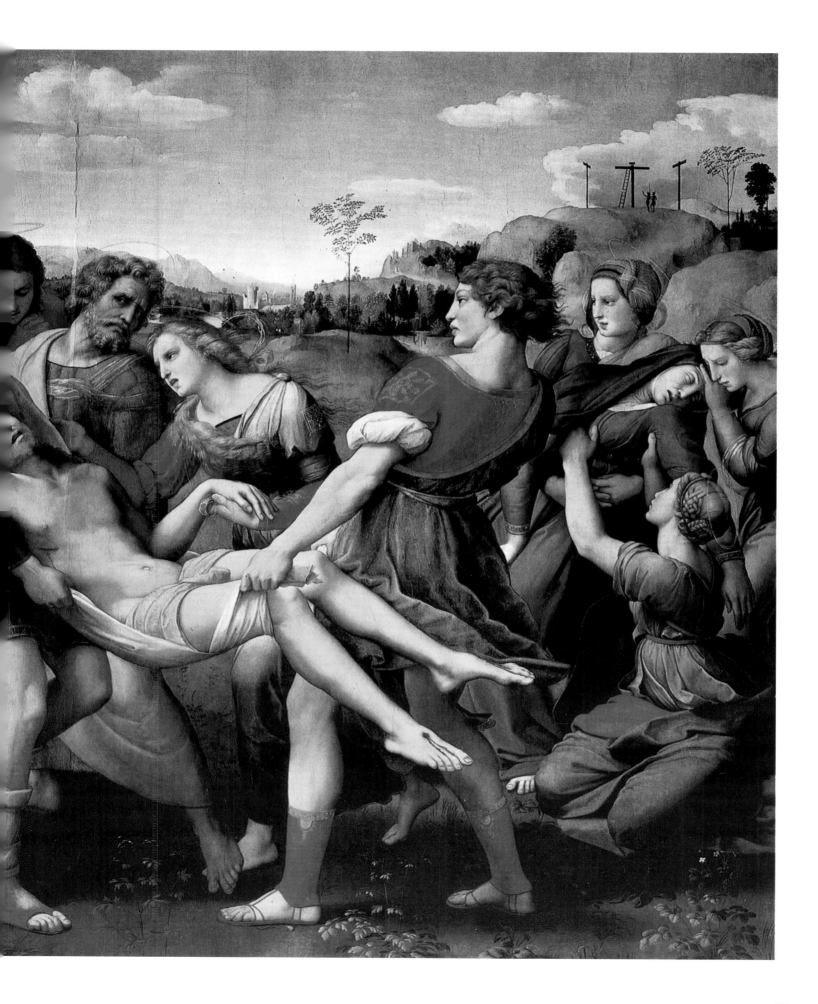

THE MADONNA OF THE CANOPY

On 20 July 1506, the wealthy merchant Rinieri di Bernardo Dei, whose luxurious family residence (today Palazzo Guadagni) had been completed not long before in Piazza Santo Spirito, bade his heirs to see that his chapel in the Santo Spirito church was fitted out with all the necessary decorations and furnishings, including a stained-glass window and an altarpiece. Rinieri died on 30 September; it is highly probable that it was his only son Piero who commissioned Raphael to paint the altarpiece. In the composition, we see both Saint Bernard, the dedicatee of the chapel as well as Piero's grandfather, and Saint Peter, after whom Piero was named, to the right of the Virgin (that is, in the most important position). But in late 1508 Raphael departed Florence for Rome and left the work unfinished. Following his death, Baldassare Turini, the executor of Raphael's will, had the altarpiece placed in his chapel in the cathedral of Pescia, completed in 1540. It was requisitioned in 1697 by Ferdinando de' Medici and taken to Palazzo Pitti.

The Madonna of the Canopy
oil on wood, 279 x 217 cm; 1507-1508
Florence, Galleria Palatina

A HOUSEHOLD ICON
Ferdinando de' Medici kept a collection of altarpieces in his apartment in Palazzo Pitti. Raphael's panel, with an addition at the top thirty-two centimeters in height, was placed in the "Chamber of the Timbrels", a music room.

THE ORIGINAL DESTINATION
Below: the Dei chapel in Santo Spirito, with a copy of the painting commissioned of Rosso Fiorentino by the Dei family in 1522. This panel was also removed by Ferdinando de' Medici and still hangs in the Galleria Palatina.

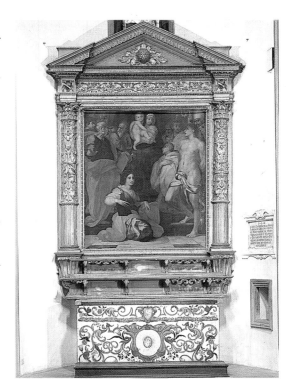

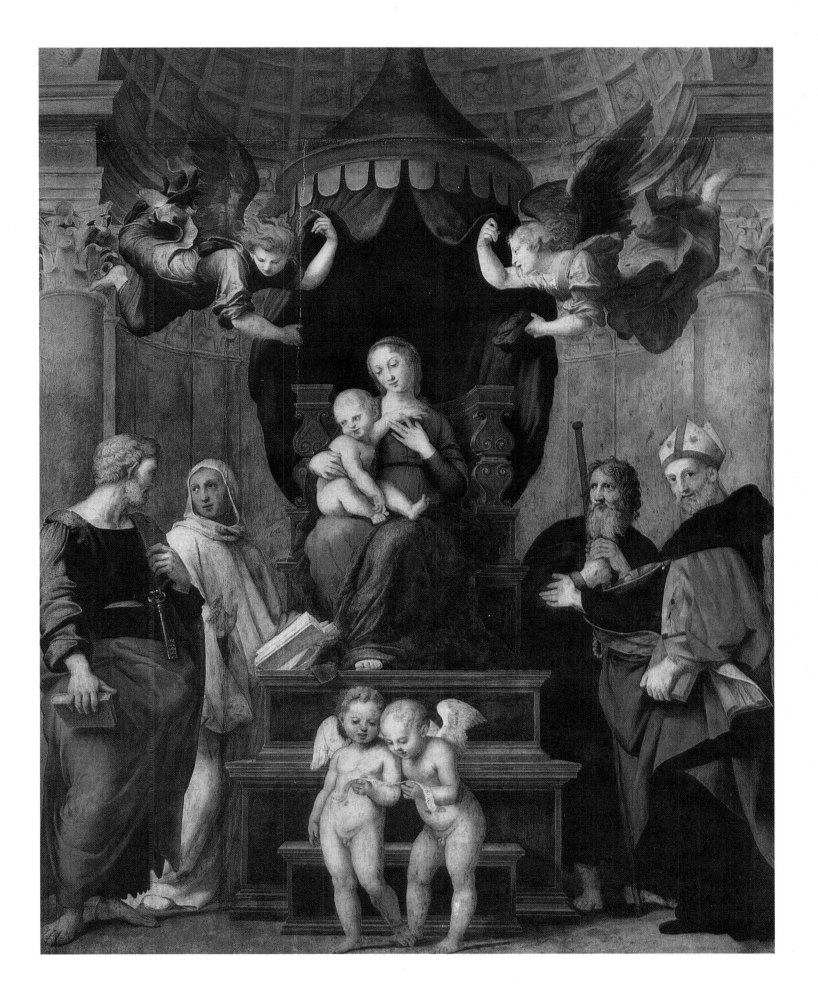

THE SCHOOL OF ATHENS

T he scene is set in a basilica-like area reminiscent of the interior of a classical building, but probably also of Bramante's plan for the new Saint Peter's. The painting is a gallery of portraits of cultural figures of the times. At the center, with the countenance of Leonardo, stands Plato holding the *Timaeus* and pointing upward, alongside Aristotle who, in counterpoint to his companion, holds the *Ethics* and turns his palm toward the ground. Euclid, with Bramante's features, stoops as he performs a measurement in right foreground; behind Epicurus, depicted crowned with vine leaves, we see Federico Gonzaga as a boy; the young man making notes in a large book, closer to the center near Pythagoras, is Francesco Maria Della Rovere. Finally, the Heracleitus in the foreground, with his elbow propped on a block of stone, is Michelangelo.

AN ADDED PORTRAIT
As can be seen from the full cartoon, in which Heracleitus is missing, Raphael added the portrait of Michelagelo when the work was already completed; that is, after Buonarroti has uncovered the first portion of the ceiling of the Sistine Chapel on 14 August 1511. Below, a detail.

A SELF-PORTRAIT
Raphael, as though to complete the coming-together of the great figures in science, philosophy and art, added his own self-portrait to the fresco. He is represented by the black-capped figure at the far right, standing next to his friend and fellow-painter Sodoma.

The School of Athens
fresco, base ca. 770 cm; 1507-1511
Vatican City, Vatican Palace,
Room of the Segnatura

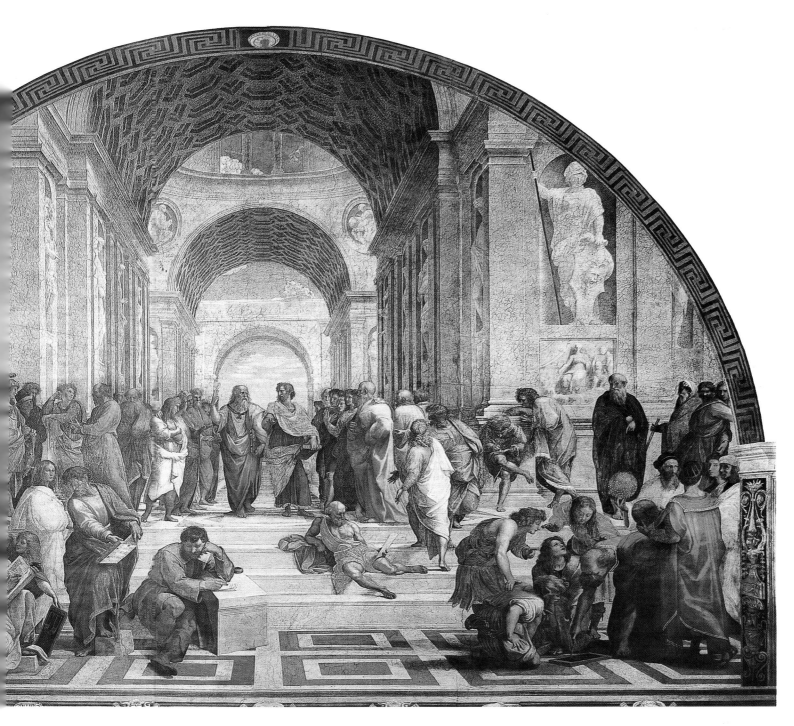

THE COMPLETE STUDY
Right: the full preparatory cartoon for the *School of Athens,* dated 1510 and today in Milan's Pinacoteca Ambrosiana.

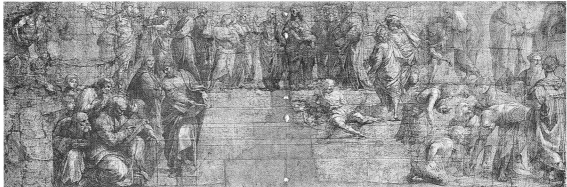

THE MADONNA DELLA SEGGIOLA

This is the portrayal of maternal love par excellence, delineated in the intimacy of an embrace. As Raphael's myth grew, it inspired artists, men of letters, and poets. The entire composition melts into a circular movement that repeats the shape of the frame; even the contracted feet of the Child contribute to creating the measure. The contrasting hues and the effect of softness in the colors are pondered to draw the viewer's attention to the fulcrum of the painting, with the cooler tones used at the edges and the warmer tones toward the center. This painting is the result of a long preparation made up not only of drawings but also of other full versions of the theme; in particular, the *Madonna della Tenda* in Munich (this page), which is instead constructed on a rectangular plan. The Virgin is seated on a luxurious *sedia camerale* reserved exclusively for high dignitaries of the papal court. It is not known who commissioned the painting, but it has been suggested that it may have been Pope Leo X himself. The work was mentioned in 1589 as being in the Tribuna of the Uffizi in Florence.

The Madonna della Seggiola
oil on wood, diam. 71 cm; 1513-1514
Florence, Galleria Palatina

THE SEGGIOLA AND THE TENDA
The figure below is a detail of the *Virgin with the Child and Young Saint John*, also called the *Madonna della Tenda* (Munich, Alte Pinakothek). Painted nearly at the same time as the *Madonna della Seggiola*, the painting has many points of contact with the latter as regards the handling of the figures.

FABLE AND MYTH
Among the many authors inspired by this painting was a certain Ernst van Houwald, who in 1820 wrote a fable relating how one day Raphael painted the daughter of a wine-seller and her two children on the cover of a barrel, so creating the *Madonna della Seggiola*.

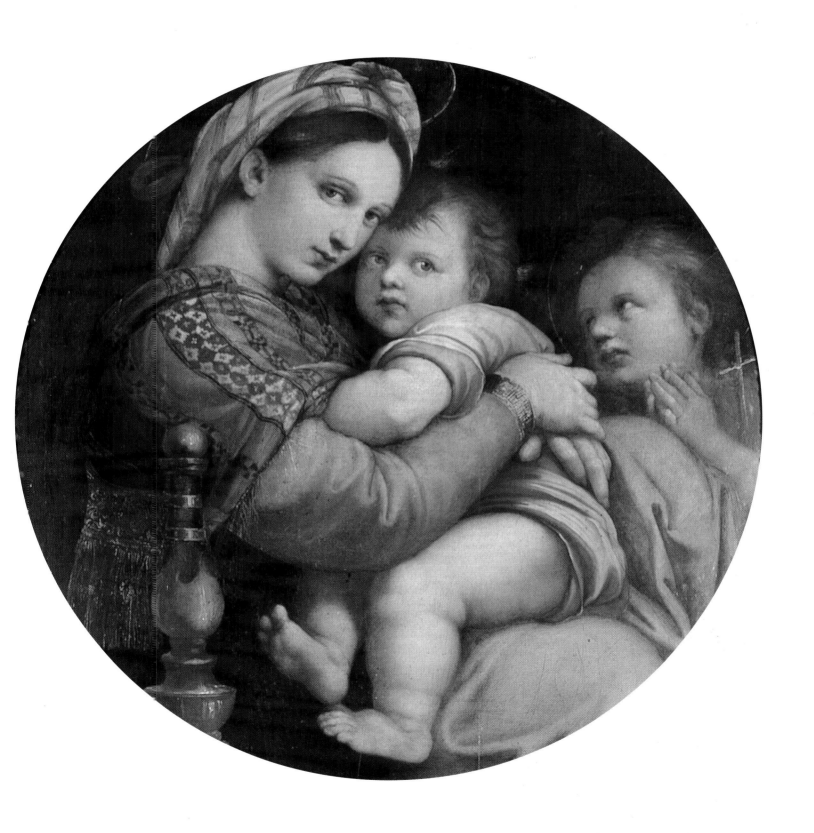

LEO X WITH TWO CARDINALS

" At Rome Raphael did a picture with the portraits of Pope Leo, Cardinal Giulio de' Medici and the Cardinal de' Rossi. [...] Among other things is the burnished gold ball of the seat, reflecting, such is its clearness, the lights of the windows, the Pope's back, and the furniture of the room like a mirror ...". Thus an amazed and wonder-struck Giorgio Vasari described this painting, which in 1518 – perhaps only shortly following its completion – was in Florence before the banquet table set for the wedding of Lorenzo Duke of Urbino and Maddalena de la Tour d'Auvergne: the former cardinal Giovanni de' Medici, son of Lorenzo il Magnifico and then Pope Leo X, wanted to be present at the event in some manner. Behind the pope are portrayed two of his protégés: Cardinal Giulio de' Medici, Leo's nephew and the future Pope Clement VIII, and Luigi de' Rossi, the nephew of Lorenzo il Magnifico. Raphael's composition was to inspire future official portraits of popes by Titian and Velasquez.

Leo X with Two Cardinals
oil on wood
155.5 x 119.5 cm; 1518
Florence, Uffizi

A POLITICAL PORTRAIT
The portrait of Leo X shown on the occasion of the marriage of Lorenzo Duke of Urbino to Maddalena de la Tour d'Auvergne was commissioned with the intent of confirming the adoption, by the Church and by the Medici family, of a policy favorable to France.

A REPAINTED BACKGROUND
Studies and research have shown that the portrait was sketched with the Pope on his chair, alone against a green drape as in the portrait of *Julius II* below (1512; London, National Gallery). In Vasari's opinion, Giulio Romano had a hand in the painting.

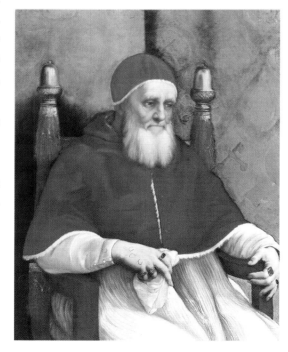

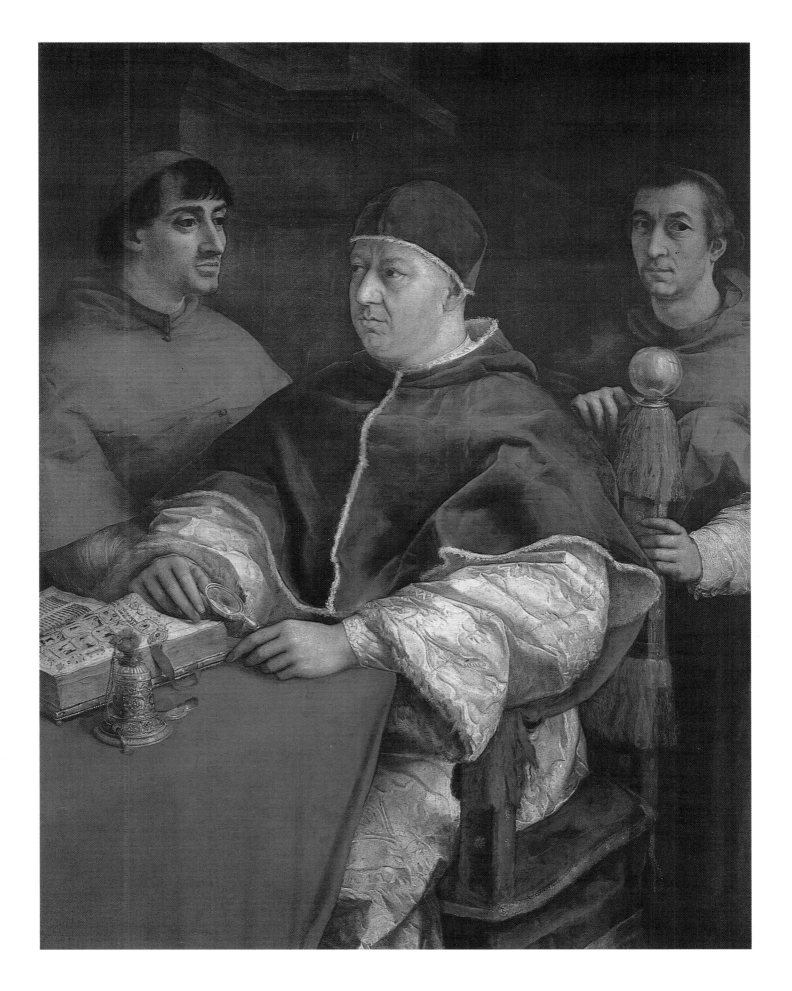

TRANSFIGURATION

The painting was commissioned of Raphael in 1516 by the cardinal Giulio de' Medici for the cathedral of Narbonne, his episcopal seat. At the same time, the cardinal had requested that Sebastiano del Piombo, a follower of Michelangelo and therefore a rival of Raphael, paint a *Raising of Lazarus* for the same destination. This was the cue for a true competition: Raphael, irritated by the comparison, painted his work alone, with no help from any of his many collaborators. He began the work sometime after July 1518 and completed it just before his death on 6 April 1520. The artist's body was laid out in the Pantheon together with the newly-finished panel (it is said that the head of Christ was painted the day before he died). Six days later, when the *Transfiguration* was displayed publicly alongside Sebastiano del Piombo's *Raising of Lazarus,* there began a rivalry between the Raphaelesque and the Michelangelesque manners that was destined to last throughout the century.

Transfiguration
oil on wood
450 x 278 cm; 1518-1520
Rome, Pinacoteca Vaticana

A SINGLE EVENT
Raphael had at first conceived the *Transfiguration* in a traditional manner, as a single event iconographically similar to the *Raising of Lazarus* and intended to occupy all the space on the panel. The episode of the healing of the child possessed by the devil was added only later.

SYMBOLIC PAINTINGS
Both Raphael and Sebastiano del Piombo (below; *The Raising of Lazarus,* 1517-1519; London, National Gallery) intended referring, with their depictions of episodes of miraculous healing, to the Medici family to which both Pope Leo X and the cardinal who commissioned the paintings, his cousin, belonged.

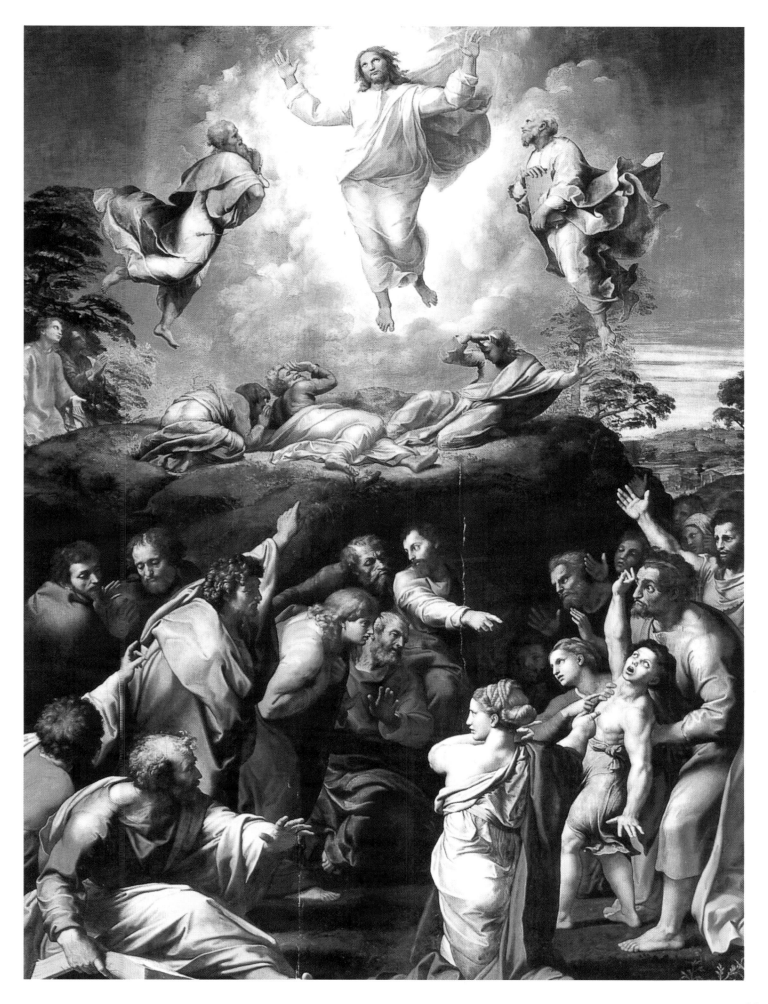

BIBLIOGRAPHY

Vasari, Giorgio. "La Vita di Raffaello." In Giorgio Vasari, *Le Vite*. 2nd ed., Florence, 1568. Gilzia, V. *Raffaello nei documenti, nelle testimonianze dei contemporanei e nella letteratura del suo secolo*. Vatican City, 1936 (new edition, Famborough Hants, 1971). Comesasca, E., ed. *Raffaello. Gli scritti, lettere. firme, sonetti, saggi tecnici e teorici*. Milan, 1994. De Vecchi, P.L. *L'opera completa di Raffaello*. Milan, 1966. Shearman, J. *Raphael's Cartoons [...] and the Tapestries for the Sistine Chapel*. London, 1972. De Vecchi, P.L. *Raffaello: la pittura*. Milan, 1981. Oberhuber, K. *Raffaello*. Milan, 1982. Jones, R. and N. Pennym. *Raphael*. New Haven - London. Joannides, P. *The Drawings of Raphael with a Complete Catalogue*. Oxford. Knab, E., E. Mitah, K. Oberhuber, S. Sherman. *Rapheal. Die*

Zeichnungen. Stuttgart. Sherman, J. *Funzione e illusione, Raffaello, Pontormo e Correggio*. Milan. Pope-Hennessy, J. *Raphael*. London, undated; Turin, 1983
Urbino e le Marche prima e dopo Raffaello. Milan. *Lo Sposalizio della Vergine di Raffaello. Raffaello giovane e Città di Castello*. Brown, D.A. *Raphael and America*. Washington. *Raphaël dans les collections françaises*. Paris. *Raffaello a Roma* (Symposium Proceedings). Rome, 1986. *Raffaello in Vaticano*. Vatican City. Gregori, Mina, ed. *Raffaello a Firenze* (Catalogue of Florentine exhibit). Milan. *Aspetti dell'arte a Roma prima e dopo Raffaello*. *Raffaello architetto*. Capitoline Museums Catalogue. Rome. Beguin, S. *La peinture de Raphaël au Louvre*. Paris. *Studi su Raffaello* (Proceedings of International Conference). Urbino-Florence, 1987. Mancini, F.F. *Raffaello in Umbria*.

Cronologia e committenza. Perugia, 1987. Ferino Pagden, S. and M. Zancan. *Raffaello. Catalogo completo dei dipinti*. Florence, 1989. Pedretti, C. *Raffaello*. Florence, 1989. *Raffaello a Pitti, La Madonna del Baldacchino. Storia e restauro*. Florence, 1991. Villa Medici, Cordellier, D. and B. Py, eds. *Raffaello e i suoi*. Rome, 1992. *Raffaello nell'appartamento di Giulio II e Leone X*. Milan, 1993. Todini, F. "Una crocifissione del giovane Raffaello a Perugia" in *Studi di Storia dell'arte*, I, 1990-1991. Natali, A. and A. Del Serra. In "Il restauro di Leone X e di Tre capi d'opera del Cinquecento" in *Gli Uffizi - Studi e Ricerche - I*. Insert 28, Florence, 1996. Zuccori, A. *Raffaello e le dimore del Rinascimento*. No. 7, November 1986.

REFERENZE FOTOGRAFICHE

Archivio Giunti Per quanto riguarda i diritti di riproduzione: l'editore si dichiara pienamente disponibile a regolare eventuali spettanze per quei materiali di cui non sia stato possibile reperire la fonte. Per quanto riguarda le didascalie, quando non altrimenti indicato, l'opera fa parte di collezione privata.

Finito di stampare nel mese di maggio 1998
presso Giunti Industrie Grafiche S.p.A. – Stabilimento di Prato